STRAWBERRY
FIELDS

ABRAMS, NEW YORK
in association with the Central Park Conservancy

STRAWBERRY FIELDS

CENTRAL PARK'S MEMORIAL TO JOHN LENNON

SARA CEDAR MILLER

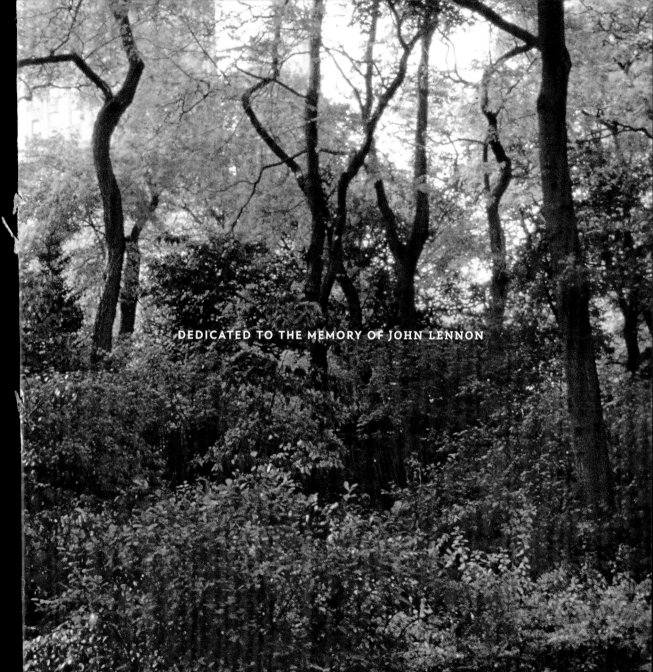

DEDICATED TO THE MEMORY OF JOHN LENNON

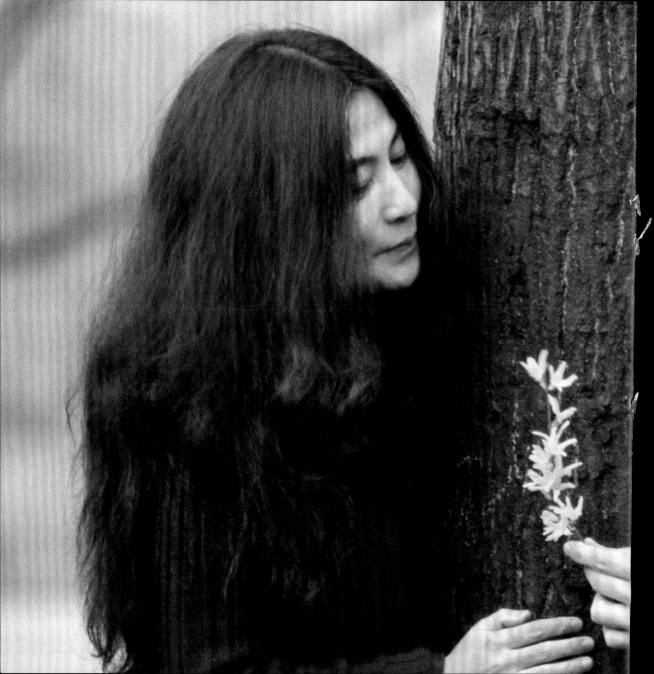

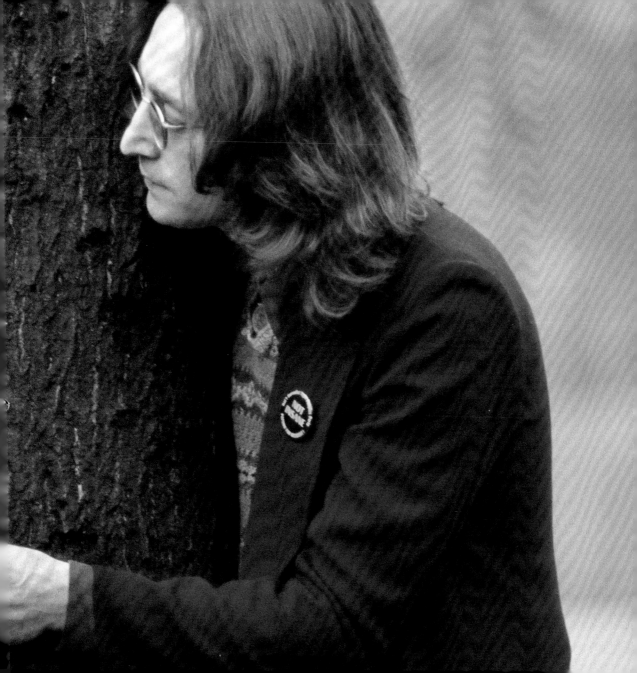

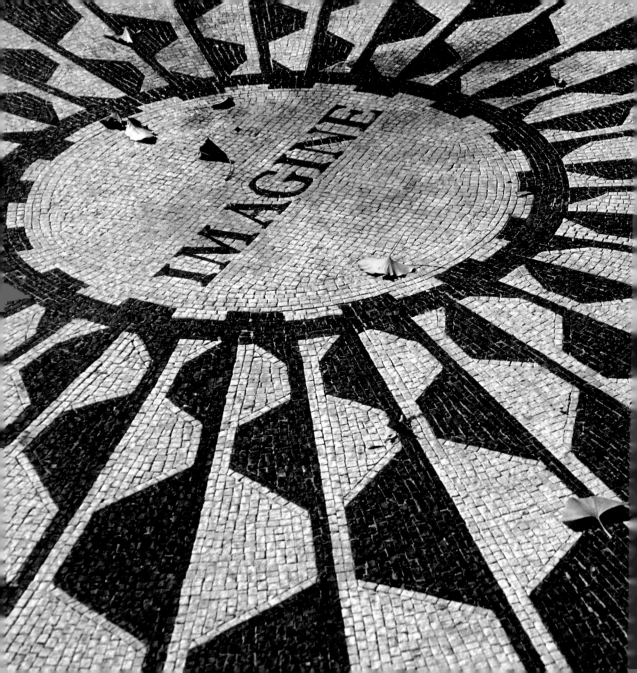

CONTENTS

FOREWORD

DOUGLAS BLONSKY, President, Central Park Conservancy and Central Park Administrator

Strawberry Fields is today one of the most visited sites in Central Park. There are the local New Yorkers who visit daily—to walk the dog, meet a friend, have a picnic, read the paper, or smell a rose—and the fans, who may come only once in a lifetime to pay tribute to the life and art of John Lennon. What they all have in common is an appreciation for Yoko Ono, who imagined this beautiful and sensitive landscape dedicated to world peace and harmony.

We at the Central Park Conservancy are proud to celebrate the twenty-fifth anniversary of Strawberry Fields, dedicated on October 9, 1985, on what would have been John Lennon's forty-fifth birthday. When the landscape opened to the public that day, the Conservancy was still a fledgling organization, having been established only five years earlier as a new kind of partnership whose goal was to assist the City of New York with private funding and professional management toward the restoration and maintenance of the Park's severely deteriorated landscapes and structures.

Strawberry Fields plays an important role in the story of Central Park's rebirth. It was the Park's first major landscape to be planned, designed, and constructed with Conservancy funding, and it was sponsored by the Conservancy's first million-dollar donor, Yoko Ono. Ms. Ono understood that it was not only important to create a beautiful and healthy landscape, but also to provide the funds for its daily maintenance, a policy that ensures the Park will remain beautiful for future generations.

Unlike its predecessors, the Central Park Conservancy has, for the past thirty years, been able to maintain this high level of care partly because of its innovative zone gardener system. Each of the park's forty-nine zones is assigned to a professional gardener, who is responsible and accountable for his or her section. It was in Strawberry Fields, through Yoko Ono's gift, that this policy was first implemented, and it set the standard for all other Central Park landscapes. Today we are happy to have Bobbi Kravis as the Strawberry Fields' zone gardener, a talented horti culturist who, with her dedicated volunteers, guarantees the beauty and health of this living memorial throughout the year.

The Conservancy relies on supporters like you to help maintain this beautiful part of the Park. The Conservancy will dedicate the proceeds from this beautiful book toward the maintenance of Strawberry Fields and its surrounding landscapes.

We also invite you to join us as a member of the Conservancy, to ensure that visitors to *all* of Central Park's magnificent landscapes will continue to celebrate and uphold the underlying message of John Lennon's song "Imagine," which echoes the same utopian ideals that were the inspiration for the creation of Central Park more than a century and a half ago. For more information about Central Park and the Central Park Conservancy, visit our website at www.centralparknyc.org.

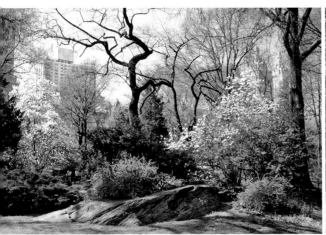
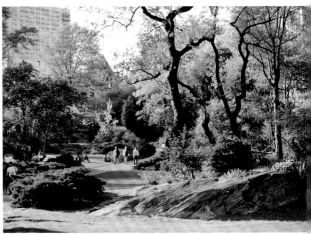

CENTRAL PARK'S STRAWBERRY FIELDS

"Landscape moves us in a manner more nearly analogous to the action of music than anything else."
—FREDERICK LAW OLMSTED, co-designer of Central Park[1]

BEFORE STRAWBERRY FIELDS

Before construction of Central Park began in 1858, the area south and west of the present Strawberry Fields site was on the edge of Harsenville, a hamlet of five hundred people, bounded on the north by Eighty-first Street, on the east by Central Park West, on the south by Sixty-eighth Street, and on the west by the Hudson River. Much of the land was owned by Jacob Harsen, a Dutch farmer whose family had arrived in the area in 1763.[2]

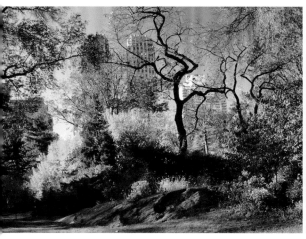
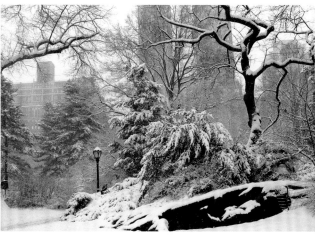

The road leading into Harsenville from the east was known as Harsen's Lane. Built in 1803, it crossed the present Central Park in a straight line at present-day West Seventy-first Street, with homes scattered along its route. Today, the more curvilinear Olmsted & Vaux Way—formerly the Seventy-second Street Cross Drive—follows much of the original road.

By the 1890s the original settlement was nothing more than a memory, having been replaced with lavish townhouses and some of the city's first apartment buildings. Today, the only reference to the former rural community is the modern Harsen House at 120 West Seventy-second Street, just two blocks from Strawberry Fields.

THE ORIGINAL PLAN FOR THE SITE

In the 1858 Greensward plan for the future Central Park, the designers Frederick Law Olmsted and Calvert Vaux envisioned the 5.3-acre landscape that is now Strawberry Fields as a perfect location for the Park's main dining establishment. In 1863 Vaux described the designers' intentions for the area:

When laying out the plan in the first instance, we considered it necessary that a site should be specially appropriated and set apart for an extensive establishment for purposes of refreshment. We felt that it should be so situated as to command fine views of the interior scenery of the Park, and yet be a little out of the line of the general promenade. . . . The site recommended was the plateau on the top of a hill on the west side, which overlooks the lake shore road, the lake, and the Ramble beyond. . . . It commands some of the finest views in the Park. . . . It also has the advantage of being . . . insulated from the rest of the design . . . surrounded on all sides by a carriage road, and it may be freely devoted to the purpose of a restaurant on an extensive scale, without

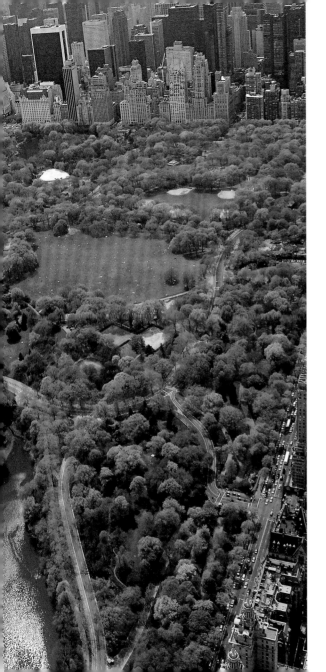

entailing any sacrifice of peace or quietness on the part of the visitor. . . . [3]

On the plan the designers called their restaurant the Casino. Today the name conjures up the glitzy gambling palaces of Las Vegas, but to proper Victorians of the nineteenth century, the word simply implied a covered cottage providing shade in a garden or park.

By 1862 much of the lower Park was opened to the public. Since no refreshment opportunities existed in the Park at that point, entrepreneurial New Yorkers set up "stands and refreshment houses" on sidewalks near the Park's entrances. The commissioners complained that they were not only very unsightly, but very objectionable," In large part because they sold alcoholic beverages. Despite the resolution of the mayor, George Opdyke, to forbid these disreputable operations, the Common Council—one of the most corrupt bodies of politicians in urban America at the time—overrode his bill, and approved the erection of a "refreshment saloon" at the western entrance to the Park. In reporting this problem in the *Sixth Annual Report*, the commissioners inserted on the opposite page Vaux's charming design for the future Casino to reassure the public that they had every intention of erecting the restaurant as soon as possible.[4]

In July 1864, the Casino and its surrounding landscape—today's Strawberry Fields—was still undeveloped, and a frustrated Calvert Vaux obliquely addressed the Park commissioners in a letter to the editor of the *New York Times*, where he reiterated the designers' intention for a restaurant:

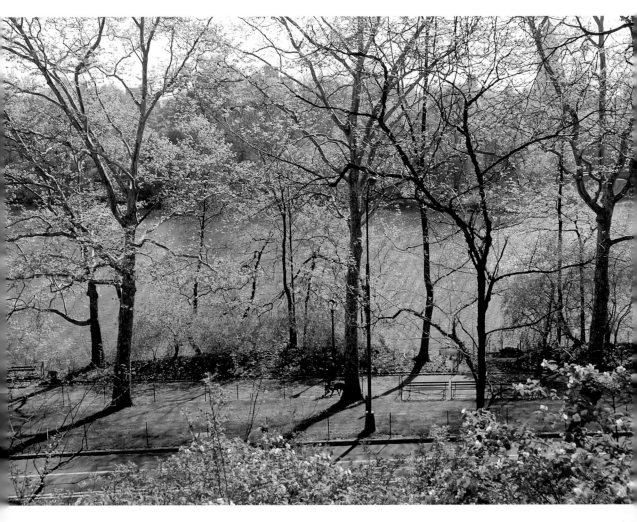

OPPOSITE: Strawberry Fields
is the teardrop-shaped area at
the bottom of this aerial view.
Sheep Meadow and Heckscher
Ballfield are visible above it.

ABOVE: A view of the Lake
from Strawberry Fields.

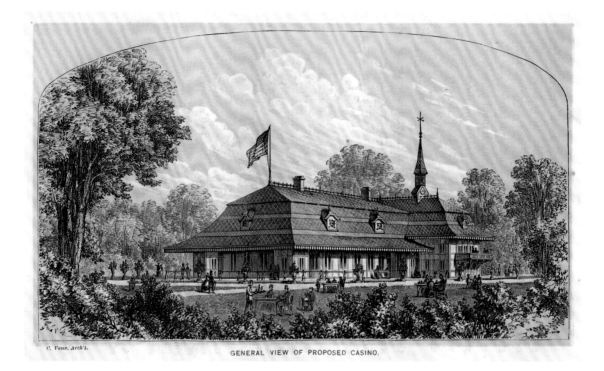

C. Vaux, Arch't.

GENERAL VIEW OF PROPOSED CASINO.

. . . [t]he proper time, in the judgment of those who have control over the Park, does not seem to have arrived for the erection of these buildings; but as a growing need is felt to exist for a first-class restaurant within the limits of the Park, in which the public at large may be properly accommodated, it is presumed that this portion of the plan will sooner or later be carried into execution.[5]

Aside from the main restaurant, the Park also needed to provide Victorian women and children with a comfortable and safe dining hall when unaccompanied by a male escort, so in 1863 the commissioners built a small, intimate cafe of Vaux's design intended to be called the "Ladies' Refreshment Salon" above the Mall, on what is today's Rumsey Playfield. In 1864 the commissioners admitted that the newly opened Ladies' Refreshment Salon—"a well-ordered and cleanly place"—which they referred to as the Casino, could not be "confined to the purposes which it was intended, [that is], a house in which to serve light refreshment to ladies and children," until the larger restaurant was erected on the current Strawberry Fields site.[6]

The larger restaurant was never built. By 1873 the little Casino above the Mall was enlarged to become the Park's main dining establishment, officially abandoning the

designers' original plan for the west-side plateau. That site was redesigned, substituting an open meadow for the restaurant. The meadow was surrounded on three sides by deciduous trees with evergreen trees clustered around its numerous rock outcrops. There were excellent views of the Lake. No paths were designed for the landscape, as the west side in the 1870s was still a rural, undeveloped area with small farms and barnyard animals. But all of that would change in 1880 when a new building called the Dakota began to rise on the perimeter of the Park at Seventy-second Street—a building that would alter the Park's western skyline forever.

EDWARD CLARK'S DARING PLAN

Women's Gate, the name assigned in 1862 to the Park entrance at West Seventy-second Street, is oddly appropriate, since the developer of the Dakota, Edward Clark, amassed his fortune as co-owner of the Singer sewing machine company, whose best-selling nineteenth-century appliance provided contemporary women with the opportunity to achieve a measure of economic freedom and independence.[7]

It is not without considerable irony that Clark's partner, Isaac Merritt Singer, who was the inventor of the Singer machine embraced by Victorian women, was both a polygamist and an obsessive womanizer. He began his working life as an actor, particularly noted for his tall, dark, and handsome physique. He had five simultaneous marriages, and his wives had absolutely no knowledge of the other four alliances. The debonair Singer was also supporting as many as six mistresses and countless

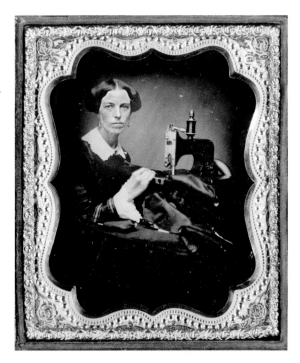

OPPOSITE: Calvert Vaux's 1864 concept for the Park's formal restaurant, intended for the area that is now Strawberry Fields. The restaurant was never built.

ABOVE: The sewing machine dramatically changed women's lives in the nineteenth century. The machine invented by Isaac Singer became the most popular model. It was, in part, the great fortune amassed by the Singer company that helped to subsidize the construction of the Dakota.

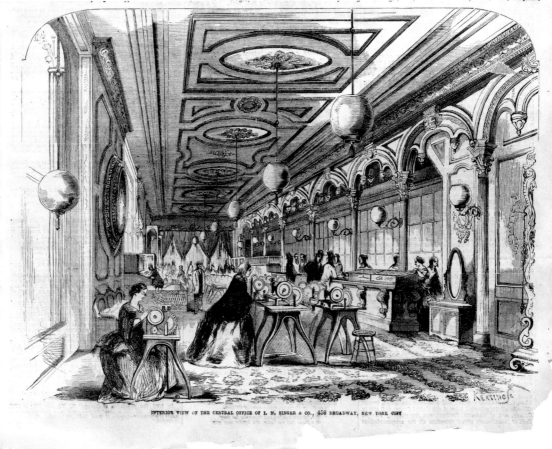

INTERIOR VIEW OF THE CENTRAL OFFICE OF I. M. SINGER & CO., 458 BROADWAY, NEW YORK CITY

ABOVE: The central office of I. M. Singer Sewing & Company on Broadway in Manhattan. Edward Clark—company president, marketing genius, and creator of the Dakota—first conceived the idea of paying by installment plan and offered customers this option when they bought a Singer sewing machine. Clark also conceived the first modern advertising campaign, making famous the expression "a stitch in time saves nine."

OVERLEAF, LEFT: John Lennon and Yoko Ono chose to live in the Dakota in part because of its proximity to Central Park. The view of the Park's Lake was particularly pleasing to them.

OVERLEAF, RIGHT: Carved into the stone of the Dakota and flanking the main entrance are portraits of Isaac Singer and his wife, Isabella.

children. In his will he acknowledged twenty-five offspring, only eight of which were from his "legitimate" marriages. Interestingly, the last of his wives, Isabella Singer—the one with whom he spent his last years—went on after his death to live in Paris, where she became Bartholdi's model for the face of the Statue of Liberty.

Singer had a lot of mouths to feed, and wandered from job to job. Fortunately, he was as clever an inventor of machines as he was of alibis. Working in a Boston machine shop, he was given the task of fixing one of the new sewing machine models. "Suddenly," as author Stephen Birmingham tells it, "it was as if some long-buried resource . . . burst to the surface and flashed like a comic-strip light bulb above his head." Within days Singer's machine had produced "an even, single-thread chain stitch that no other machine had ever been able to produce before."[9] It is still the one that is used today.

Before Singer could form his own company and produce the new and improved version of the machine, he had to gain the legal rights to use at least twenty-five other patents, including the most famous one belonging to Elias Howe, who invented the first sewing machine. In exchange for these legal services and some personal ones as well, Singer's attorney, Edward Clark—"a tough-minded huckster with a promoter's instinct and no small talent for making deals"[10]—demanded fifty percent of the I. M. Singer Company. When Singer died in 1875, Clark became president of the company, and with the great fortune that he had amassed, made yet another leap into what most New Yorkers considered a very risky business—the building of the Dakota apartments.

Among his many talents, Edward Clark was an astute demographer and social visionary. He understood that men like himself were part of a new class of monied and cosmopolitan New Yorkers, who demanded an elegant lifestyle, luxury housing, and a neighborhood to call their own. Clark also understood that his emerging class of *nouveau riche* did not have the means to build sumptuous mansions like those being built to the south and east of the Park by Mrs. Astor's "Four Hundred," the crème de la crème of New York wealth and society. They *could*, however, afford to live in an apartment building that would have the same kind of material splendor and grandeur as that of the Vanderbilts' or the Astors' *and* have the Park outside their front door. Thus was born his plan for the Dakota apartments.

THE RISE OF THE NEW YORK APARTMENT HOUSE

Just before becoming the codesigner of Central Park in 1857, British-born architect Calvert Vaux had been the first to propose that New Yorkers build "French flats," as rents were high and land for new private homes was both scarce and exorbitant. But the idea of apartments was abhorrent to most mid-nineteenth-century Americans, who preferred above all else to live in single-family homes. Proper Victorians, it was felt, would never live "on shelves under a common roof," as they were considered to be "inducements to immorality," not unlike the disreputable behavior conducted in hotels or tenements.[11]

It was French-trained architect Richard Morris Hunt, a colleague of Vaux's, who managed to build the first American apartment building in 1869. Called the

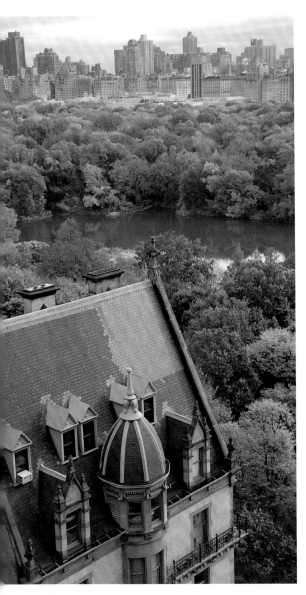

Stuyvesant, after the family who owned the property, Hunt converted a row of townhouses on Eighteenth Street and Irving Place into fashionable French flats. They were an immediate success among the bohemian class of writers, publishers, and artists, and Calvert Vaux was one of the first tenants to move in.

By the early 1870s private mansions and townhouses were being constructed on the eastern edge of the Park; new apartment buildings started to go up on the southern edge, but it wasn't until after the completion of the American Museum of Natural History in 1877 that development became a possibility on the western perimeter. That was the year Edward Clark purchased two acres of undeveloped land on the corner of Seventy-second Street and Eighth Avenue (now Central Park West) for two hundred thousand dollars (or in today's market, more than four hundred million dollars).[12] Clark purchased the land for the Clark Apartments from former Central Park commissioner August Belmont, one of the richest men in America. As the American representative of the Rothschild banking family, Belmont preferred to live in New York's wealthiest neighborhood, on lower Fifth Avenue. He never showed any interest in a residence anywhere near Central Park, but as an astute investor, he knew the property on the Park's perimeter was an extremely wise investment.

THE DAKOTA

As the location for a vast apartment building, the Upper West Side was so remote—most people in Manhattan still lived below Forty-second Street—that a friend of Clark's teased him that his building would practically be in the

Dakotas, one of the faraway Western territories. Clark so enjoyed the metaphor that "in a gesture of airy defiance to the critics, skeptics, and naysayers" who were convinced that his investment would fail, he decided to change the name of his venture from the Clark Apartments to the Dakota.[13] Eighth Avenue, despite the completion of the Park in 1873, was still a dirt road, and the surrounding land for the new Dakota featured small shanties and kitchen gardens "whose owners kept pigs, goats, cows, and chickens that often foraged among the rocky outcroppings of the new Park." Park police were ordered to shoot them if they were caught dining on the newly planted trees and shrubs.[14]

Clark broke ground in 1880, his budget being an unprecedented one million dollars. Soon afterward he proceeded to pour another million dollars into what New Yorkers began to call "Clark's Folly."[15] The architect of the building was Henry Hardenbergh, whose Dutch ancestors could be traced to the founding of New Amsterdam. The architect, who would eventually design the Plaza Hotel at the southeast entrance to Central Park, had recently designed the Vancorlear Hotel, consisting entirely of suites of rooms. Clark gave his architect carte blanche, and Hardenbergh pulled out all the stops, designing an eight-story hollow cube with elaborate embellishments such as "ledges, balconies, decorative iron railings and tall columns of bay windows climbing eight stories high. A tall-gated archway, flanked by iron planter urns, provided the main carriage entrance. . . . In the center was a courtyard with two stone fountains, each spouting a dozen iron calla lilies. . . . The Dakota's roofs resemble a miniature European town of gables, turrets, pyramids, towers, peaks,

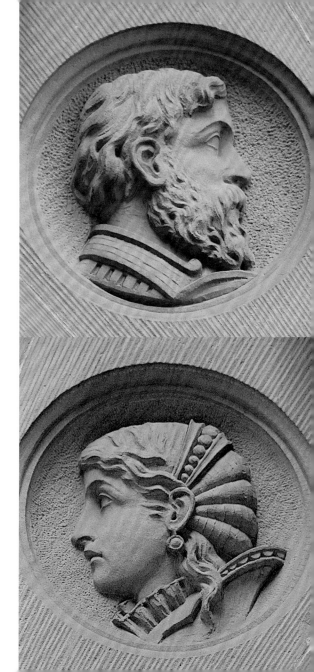

wrought-iron fences, chimneys, finials, and flagpoles."[16] Flanking the main entranceway are carvings of Isaac Merritt Singer and his wife, Isabella.

In 1884 Clark's first tenants moved into the most lavish residential apartment building in New York City's history. In spite of its neighbors and the remoteness of the neighborhood, the Dakota was an immediate success. Like the residents of the Stuyvesant, the first generations of the Dakota's tenants were a bohemian bunch who distinguished themselves from old money and thought of themselves as the city's cultural and artistic leaders. Such residents as Theodore Steinway, the piano magnate, and Gustav Schirmer, the music publisher, led the way. Their frequent guests included such renowned musicians as composer Peter Ilyich Tchaikovsky and writers Mark Twain, William Dean Howells, and Stephen Crane. Artists comprise the majority of Dakota residents to this day: Leonard Bernstein, Rudolph Nureyev, Roberta Flack, Rosemary Clooney, Judy Garland, Boris Karloff, Gwen Verdon, Teresa Wright, and Lauren Bacall are just some of the best-known artists who have lived in the Dakota through the years. In part, it was this grand tradition that drew John Lennon and Yoko Ono to the building.

THE DAKOTA YEARS: JOHN LENNON & YOKO ONO

Although Yoko had lived in New York City for long periods in the 1950s and 1960s, John and Yoko together moved to the city from England in August 1971. Four months later they

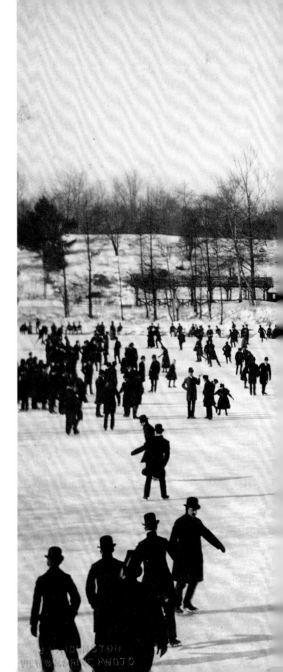

RIGHT: Skating on the Lake in Central Park, c. 1890, with the newly constructed Dakota and the landscape that would become Strawberry Fields in the background.

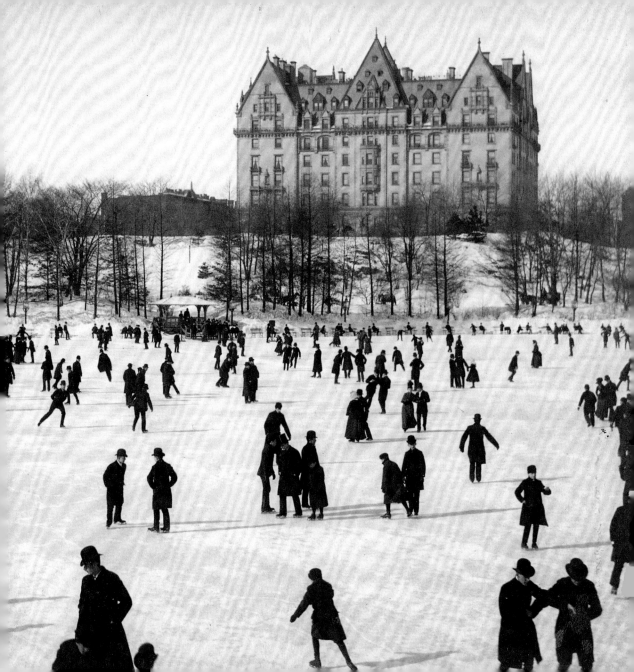

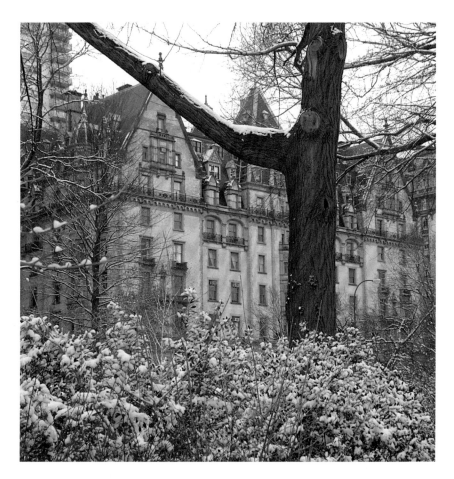

OPPOSITE AND ABOVE: Views of the Dakota from Strawberry Fields. In 1884 the *Daily Graphic* of New York wrote that "the Dakota guaranteed to the tenants comforts which would require unlimited wealth in a private residence." The Dakota was also built to protect its tenants against the noise and stench of New York's streets. The walls were up to twenty-eight inches thick and "between each layer of brick flooring was a layer of Central Park mud . . . for soundproofing and fireproofing."

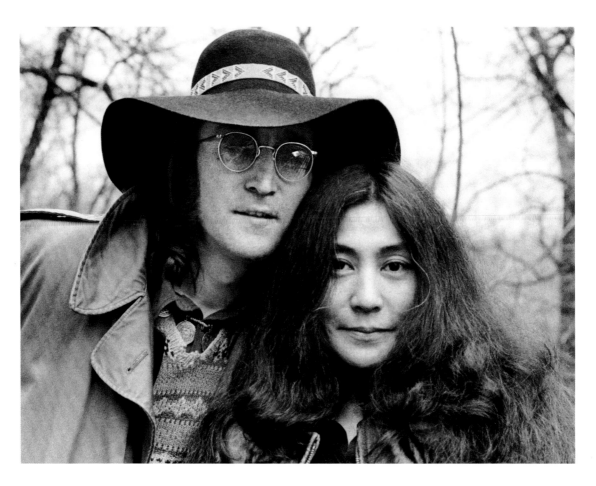

ABOVE: John and Yoko in Central Park, 1973.

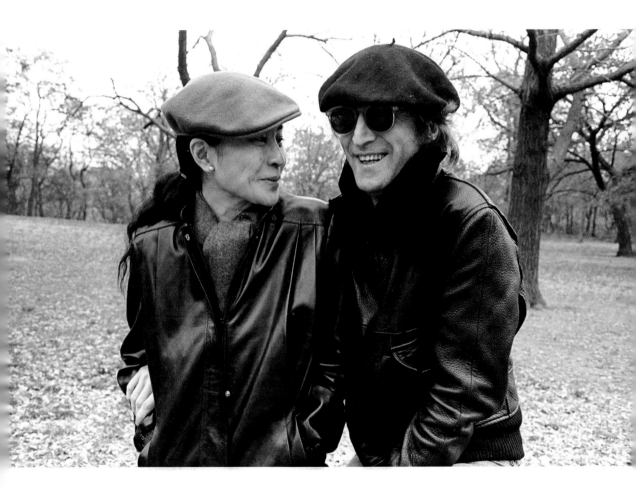

ABOVE: Yoko and John in the area that would
become Strawberry Fields, November 21, 1980.

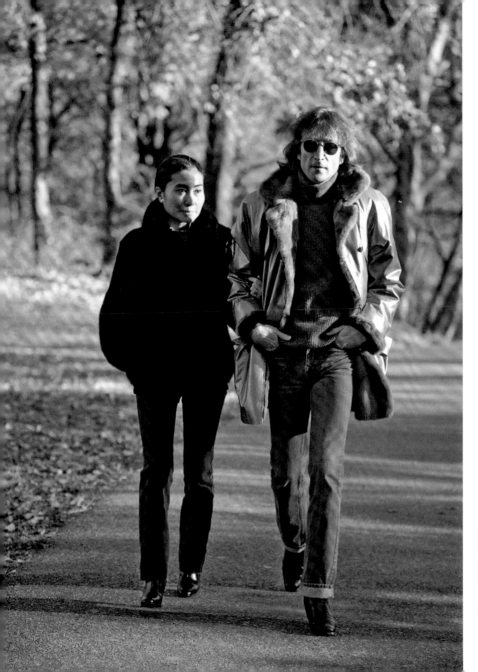

LEFT: Yoko and John on their last walk in Central Park, during the making of the video for "Woman," November 26, 1980. Five years later, this area would become Strawberry Fields.

released the single "Happy Xmas (War Is Over)." This song was written and recorded by John and Yoko and inspired by their performance art piece "War Is Over if You Want It," which was displayed on billboards worldwide in twelve cities between 1969 and 1970. In 1972 the Nixon administration took what it called a "strategic counter-measure" against John and Yoko's anti-war message, embarking on what would be a four-year attempt to deport them. It was during that time, in May 1973, that John and Yoko moved to the Dakota.

Having finally won the battle with the U.S. government in 1975, John took a much-needed respite from the pressures of his profession, and helped raise his and Yoko's son, Sean, who was born October 9, 1975, on John's thirty-fifth birthday. He was devoted to his family, evolving comfortably into a typical Upper West Sider, which included hanging out in Central Park.

John reemerged in the music world in October 1980 with a new single, "(Just Like) Starting Over," an appropriate title after his five-year absence. It was the first single on *Double Fantasy*, the album that he and Yoko wrote together, released only three weeks before his tragic death.

LAST WALK IN THE PARK

The release of *Double Fantasy* after a five-year hiatus was of great interest and excitement to everyone, including the hip downtown newspaper, the *SoHo Weekly News*. Music editor Peter Occhiogrosso sent Allan Tannenbaum to photograph Yoko for the cover of the newspaper.

After completing the cover image of Yoko in his studio on November 21, 1980, Tannenbaum requested a session at the Dakota the following day. When he hesitantly asked if he might also photograph her with John in their apartment as well as in the Park, Yoko graciously agreed. In the introduction to Tannenbaum's 2007 book *John & Yoko: A New York Love Story*, Yoko reminisced about that "relaxed" day:

> As Allan looked through his lens, we perched ourselves on the back of a Park bench, I remember it being rough on our butts.... There was no sign saying, 'The dark space behind you will one day become Strawberry Fields, where many, many people from all over the world will visit every day.' On that day in the Park we didn't have an inkling of what was right around the corner. Looking at the images, I keep asking myself how a day so normal could be so close to tragedy? You might say we were extremely lucky to have had such a day. I think so.[17]

The second session, in Central Park, occurred four days later, on November 26, when Tannenbaum was invited by John and Yoko to accompany them and a camera crew for the making of the music video for the song "Woman." It would be John and Yoko's last walk in Central Park and took place less than two weeks before John's death. They agreed to reconvene with Tannenbaum at the Dakota on the evening of December 8 to look at the prints from that day. Only hours before their appointment, Tannenbaum was rushing to make the prints in his darkroom when the editor-in-chief of the *SoHo Weekly News* delivered the devastating news of John's murder.[18]

THE VIGIL

On December 10 Yoko issued a statement asking people to meet for a ten-minute silent vigil the following Sunday at 2:00 PM. On Sunday, December 14, 1980, millions of people around the world responded to Yoko's request to pause for ten minutes of silence in memory of John Lennon. Thirty thousand mourners gathered in John's hometown of Liverpool; thousands more in Boston and Chicago; and in small towns across the nation people gathered to remember their fallen hero. The largest group—more than one hundred thousand people of all ages and backgrounds—converged on the Bandshell and Mall in Central Park. There was no formal program, no speeches—only the music. When "All You Need Is Love" was heard over the loudspeakers, the *New York Times* reported that the crowd "surged with a charge almost electric in its intensity. Suddenly thousands of hands flailed in the air, forming a sea of V's with their fingers— the familiar peace symbol" a gesture in solidarity with the sixties that John and Yoko had so frequently used.

Promptly at 2:00 PM, ten minutes of silence began. Many wept and many just embraced friends, family, and even strangers who were brought together in this sad and poignant moment. When the silence was broken, many turned their portable radios to stations playing John's song "Imagine," and the crowd sang along as they had done so many happier times before.[19]

RIGHT AND OVERLEAF: More than a hundred thousand people mourn John's death at the vigil in Central Park on December 14, 1980.

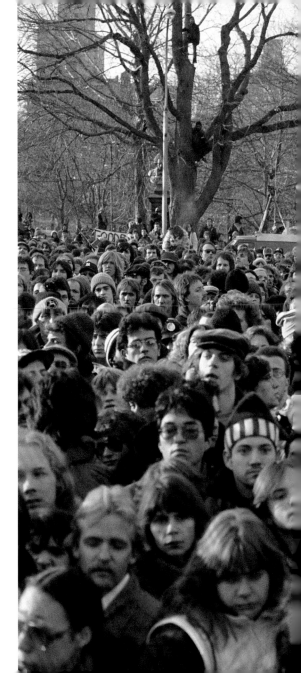

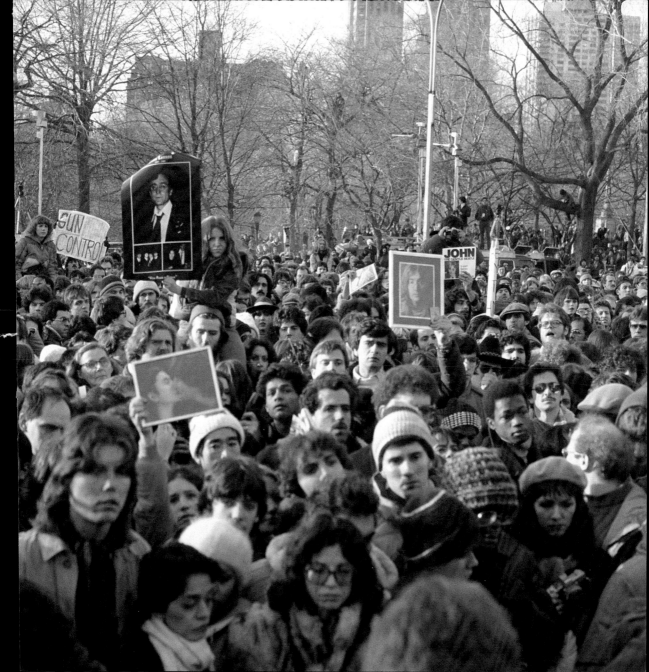

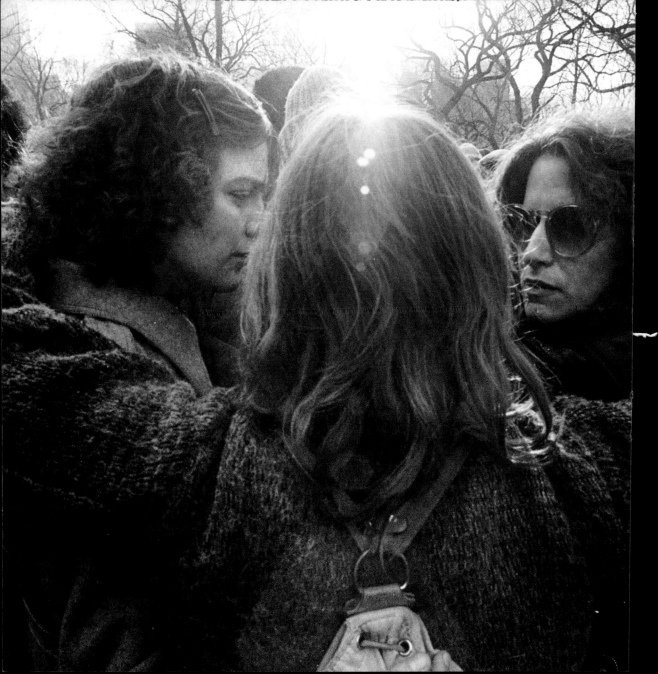

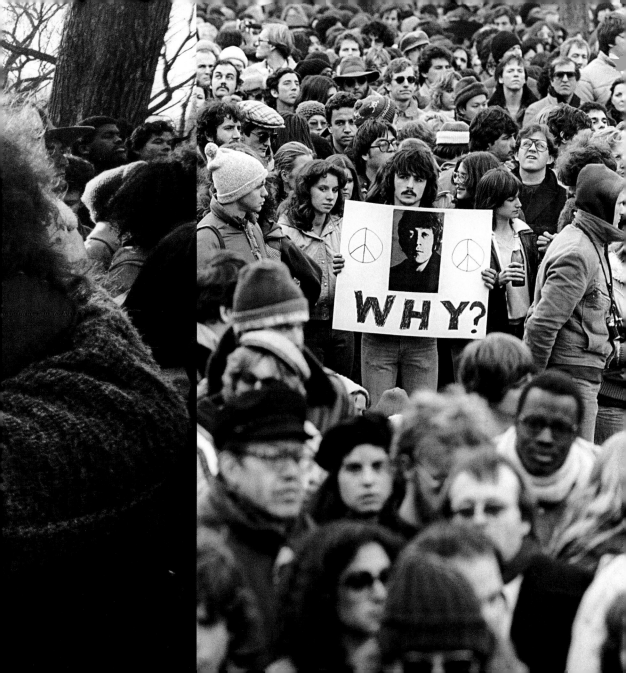

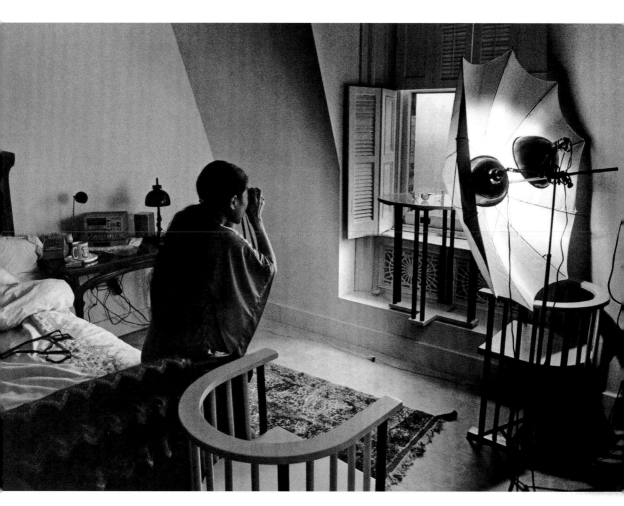

ABOVE: Yoko photographing the glasses John was wearing when he was murdered and a half-full glass of water against the backdrop of Central Park for her *Seasons of Glass* album cover. The album was one of the ways Yoko dealt with her grief, anger, and feelings of loss.

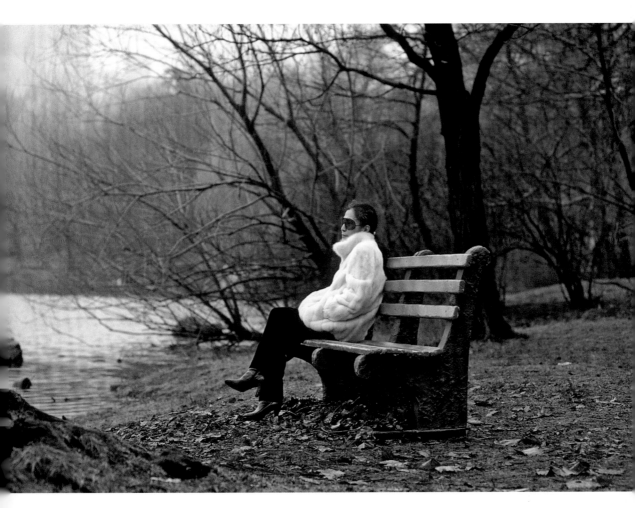

ABOVE: Yoko alone in Central Park after John's death. The sad condition of the Park in the early 1980s is evident in this image. Today, the Conservancy has restored the shoreline of the Lake.

THE PARK

Central Park was completed in 1873, exactly one hundred years before John and Yoko moved across the street from it. But in 1973 there was little to celebrate about Olmsted and Vaux's century-old masterpiece of landscape architecture. The Park was at an all-time low in a city on the brink of bankruptcy. The headline of the *New York Daily News*—FORD TO CITY: DROP DEAD—summarized the attitude of president Gerald Ford's refusal to help bail out the nation's greatest city. The Parks Department was depleted, and the job of Parks commissioner—traditionally a plum job in the administration—saw constant turnover. There were seven commissioners in eleven years from the years 1967 to 1978.

Like most of Central Park in 1980, the Strawberry Fields site was not the beautiful landscape it is today. In 1979 writer Stephen Birmingham described the desolate landscapes and the desultory attitude about civic responsibility at that time:

> *Tall weeds of lethargy and indifference seem to have grown in the Park, a sense of fatalism, and a feeling that nothing can be done was pervasive. Olmsted's dream that the Park would be a place that would be entered with a sense of reverence and respect for nature seems far short of coming true. Grassy areas have turned to dirt from the soles of too many sneakers. . . . Shrubs, plants, and flowers are routinely pulled up and carried away. Branches are occasionally*

RIGHT: A photograph taken in 1980 of an area that would become part of Strawberry Fields.

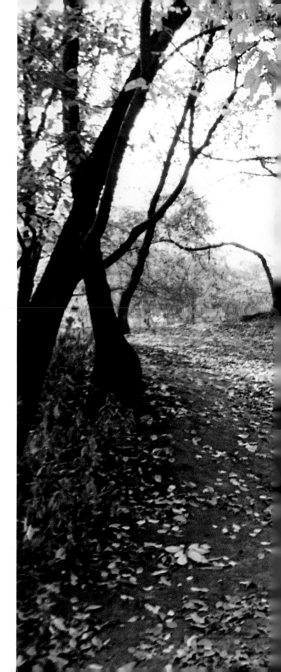

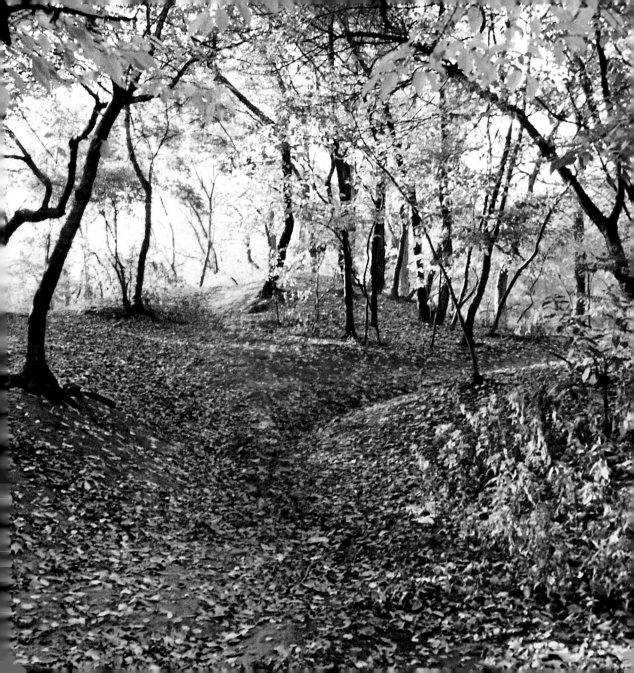

snapped from trees for a game of stickball, and statues and monuments are sprayed with graffiti. . . . A Dakota resident watched from his third-floor window as a Sunday picnic group tore up a Park bench in order to provide firewood for their barbecue.[20]

Birmingham, like most New Yorkers, realized that "maintaining this great, natural resource seems to be of low priority in New York City's scheme of allocating scarce public funds." Famous for their indomitable spirit, many well-meaning New Yorkers banded together to help clean and repair small pockets of the Park. Among them were the residents of the Dakota, who spent a Saturday afternoon cleaning their "front yard"—now Strawberry Fields. According to Stephen Birmingham, their efforts appeared to be "just the tip of the iceberg and . . . a few summer days later, the area they had cleaned was just as littered as it was before."[21]

As frequent visitors, John and Yoko had also been concerned about the poor condition of the Park. About a week before John's death, the couple was filming the video for "Woman" at the site of the future Strawberry Fields. Looking back on that day during a 1993 interview, Yoko remembered the following exchange between her and John: "'This is such a sorry spot'—it was so desolate, and nobody was caring for it. I said, 'Well, shall we donate some grass, or something?' John said, 'Yeah, that's a good idea.'"[22]

John and Yoko's sentiments were echoed by thousands of well-meaning New Yorkers, who loved the Park and watched in horror as their national treasure became a national disgrace. In 1963 Central Park was designated a

LEFT: This spot was transformed into the beautiful and welcoming entrance to Strawberry Fields.

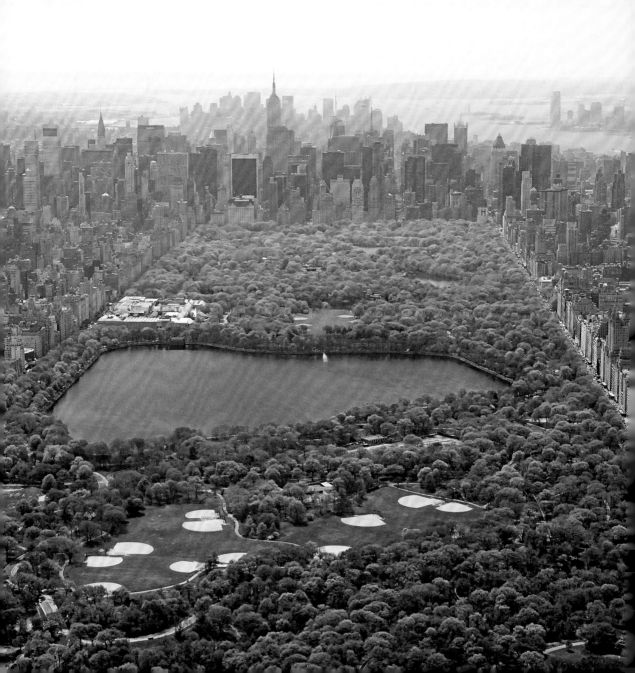

National Historic Landmark, but that recognition came without funds or leadership for improvements. In 1974, with the establishment of the New York City Landmark Commission, Central Park was named New York's first scenic landmark, protecting the land from intrusions, demolitions, or encroachment, but again, it came without a plan for its salvation. Many concerned civic leaders suggested that the Park—so central to American art, history, and culture—should become part of the National Park Service since the City had abdicated responsibility for its care.

FOUR VISIONS FOR STRAWBERRY FIELDS

The death of John Lennon coincided with—and was, in no small part, a catalyst for—the rebirth of Central Park. John Berendt, author of the best-selling *Midnight in the Garden of Good and Evil* and an editor of *Rebuilding Central Park*, saw the creation of Strawberry Fields as a groundbreaking and revolutionary event. "It set a standard, and because of its instant popularity, sparked widespread enthusiasm for the larger project that would eventually transform the entire Park. For this alone," he explains, "Strawberry Fields is a fitting memorial to John Lennon."[23]

The story of how Strawberry Fields came into being is the result of several interrelated visions:

The first vision belonged to mayor Edward Koch, Park commissioner Gordon Davis, and Central Park administrator Elizabeth "Betsy" Barlow Rogers, who founded the Central Park Conservancy only five days before the death of John Lennon.

The second vision was the one set forth by former city council member and Parks commissioner Henry Stern, who first proposed a resolution to dedicate an area in Central Park to John Lennon and name it Strawberry Fields.

The third vision was by Yoko Ono, the donor of Strawberry Fields, who wanted to create a fitting memorial to her husband in the form of an international garden of peace.

The fourth vision was by landscape architect Bruce Kelly, who worked with Yoko Ono to create the beautiful memorial under the aegis of the newly formed Central Park Conservancy.

A Public-Private Partnership:
The Central Park Conservancy

On December 3, 1980, just five days before John Lennon's death, several concerned citizens and prominent civic leaders came together in the partially restored Dairy in Central Park to hold the first board meeting of the Central Park Conservancy. The goal of the new organization was to provide funding for the restoration, management, and maintenance of Central Park in partnership with the City of New York.

With his election, Mayor Koch, a former congressman, appointed a young attorney, Gordon Davis, as Parks commissioner. Davis in turn appointed Betsy Rogers to the newly established position of Central Park administrator, whose job was to oversee the daily operations of the Park, a position that had not been filled for more than seventy years.

Rogers was chosen as administrator based on her training as a city planner and the books she'd written about New York's forests, wetlands, and Olmsted-designed parks. Rogers's unprecedented idea of a public-private

partnership took root and, as cofounder of the new organization, she provided vision and leadership for the Park's renaissance. With her indomitable spirit and what she calls the "three P's—passion, patience, and perseverance," she and her dedicated staff gradually began to transform the Park from urban jungle to urban jewel, one section at a time. Strawberry Fields was one of her first major challenges.[24]

The Naming of Strawberry Fields

Four days after the vigil for John Lennon, city council member Henry Stern introduced a resolution to the council to name the area of Central Park across from the Dakota *Strawberry Fields* as a tribute to the life and work of John Lennon. Though most council members were in favor of Stern's proposal, city council minority leader Angelo Arculeo objected to the memorial because, in his opinion, singer Bing Crosby, whom he considered "an American folk hero," was never given such a tribute when *he* died. A reporter for the *New York Post* commented that Arculeo's rejection "was believed to be the first time that any councilman had blocked a routine resolution lamenting the death of a prominent citizen."[25] Ultimately, with the strong support of Mayor Koch, the proposal passed with a vote of thirty to twelve.

On April 16, 1981, Mayor Koch held a public hearing to sign into law Introductory Number 957, sponsored by council members Henry Stern, Ruth Messinger, and Edward Wallace, along with fourteen other council members. In his remarks, Mayor Koch noted:

John Lennon's death marks the end of a tremendously creative, productive life. We will remember him for his music, his gentle and peaceful philosophy, and his need for privacy. For many of us the music of John Lennon and the Beatles is a part of our lives, and will be passed down, like all great works of art, to future generations. . . . Strawberry Fields [will be] a fitting memorial to John Lennon. It is part of the Park that he and his family loved and not far from the address where they lived.[26]

As is the custom at public hearings, citizens are invited to give remarks. One was Linda Jones, who came forward with a petition signed by 3,252 people suggesting that West Seventy-second Street be renamed *Lennon Lane*.

In the hearing, Henry Stern acknowledged *Village Voice* political reporter Jack Newfield for suggesting the name Strawberry Fields, and gave a fitting tribute to Lennon "not only for his music, but for his choosing to live in New York and for the good times that he had in New York City and the good things that he always said about New York City. . . ."[27] By the time construction began on Strawberry Fields in 1983, Henry Stern had succeeded Gordon Davis as Parks commissioner; he would, with Mayor Koch, preside over the dedication ceremony on October 9, 1985.

"Strawberry Fields, Forever" was named after what John Lennon considered one of his favorite memories. The original Strawberry Fields was a large Victorian building with extensive wooded grounds on Beaconsfield Road in Liverpool, a five-minute walk from John's childhood home. Since 1936 it had been an orphaned children's home with an annual festival, which he would attend with his aunt

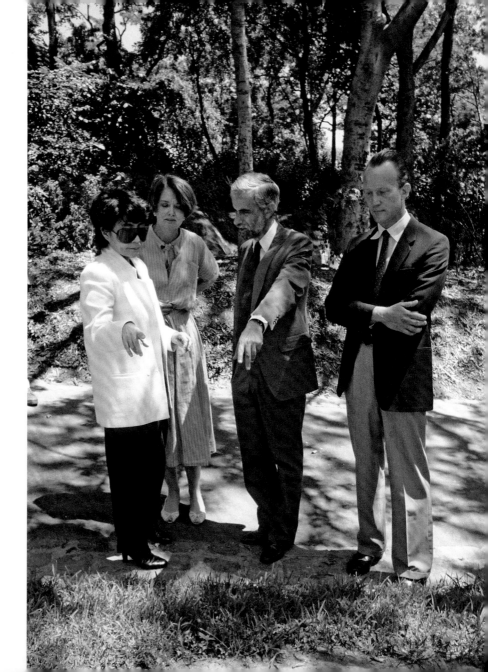

RIGHT: Yoko Ono with Central Park administrator Betsy Rogers, commissioner Henry Stern, and landscape architect Bruce Kelly, walking through the area that was to become Strawberry Fields on July 11, 1985.

Mimi. The gothic grandeur and the mystery of the forest fascinated John. It was a place he could escape to, where he could be alone and free to see the world in a different way from everyone else. Back then John felt that no one was on his wavelength, that "no one was in his tree."[28] The only remains of the orphanage today is its gatepost, which is as much a mecca for Lennon fans as New York's Strawberry Fields. Thus, the two Strawberry Fields sites are a pair of bookends that represent the beginning and end of the artist's life.

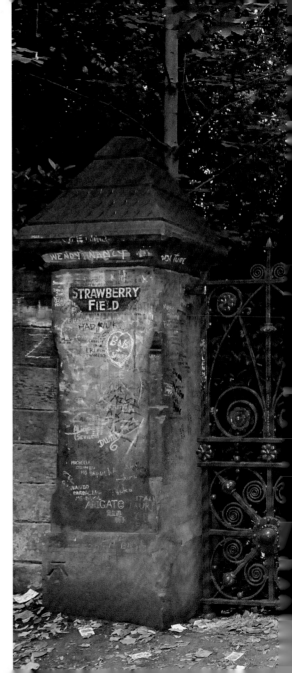

RIGHT: All that remains of the orphanage called Strawberry Fields in Liverpool, England, is the entrance gate, seen here. When he was a child, John Lennon and his aunt Mimi would visit the orphanage's annual fair. Back then the gates were a more muted red.

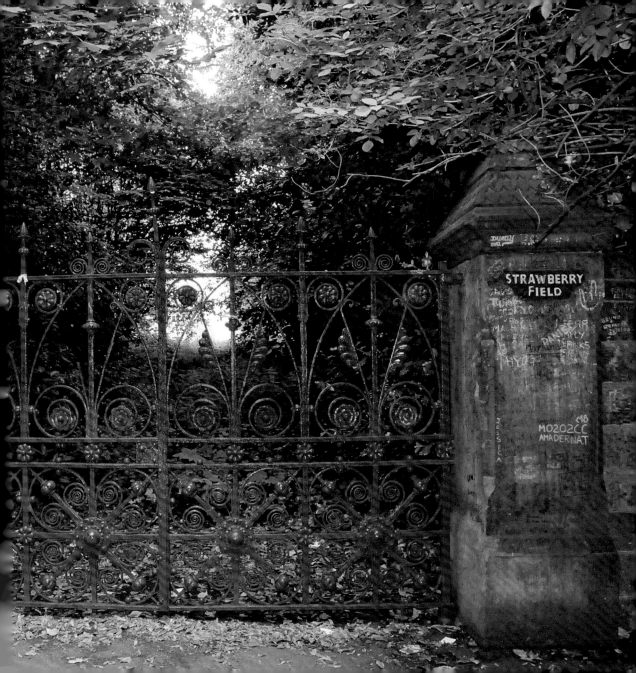

Strawberry Fields Forever

In Memory of John Lennon, New York City has designated a beautiful triangular island in Central Park to be known as Strawberry Fields. It happens to be where John and I took our last walk together. John would have been very proud that this was given to him, an island named after his song, rather than a statue or a monument.

My initial thought was to acquire some English and Japanese plants and give them to the park commission to be planted in Strawberry Fields. But somehow that idea was not quite in the spirit of things. Then I remembered what John and I did when we first met over ten years ago. We planted an acorn in England as a symbol of our love. We then sent acorns to all the heads of state around the world, inviting them to do the same. Many responded saying that they enjoyed the experience.

So in the name of John and Yoko, and spirit of love and sharing, I would like to once again invite all countries of the world, this time to offer plants, rocks and/or stones of their nations for Strawberry Fields. The plants will eventually be forests, the rocks will be a resting place for traveling souls, the bricks will pave the lane John and I used to walk on and the circle where we used to sit and talk for hours. It will be nice to have the whole world in one place, one field, living and growing together in harmony. This will be the nicest tribute we could give to John. The acorn we planted a decade ago is now a tree. I would like to obtain a twig from it to be transplanted on the island. Maybe we could add a moonstone or a pebble from Mars, so as not to shut out the universe. The invitation is open!

Copies of this note will be sent to Mayor Koch, who has been a major inspiration behind the designation of Strawberry Fields, and to the heads of state throughout the world. Let me take you to Strawberry Fields.

Love,

Yoko Ono
New York City
19 August 1981

It is requested that all offers of plant materal, rocks and stones be presented first in writing, accompanied by a color photograph and mailed to:

Strawberry Fields c/o Studio One
1 West 72 Street, New York City, NY 10023

P. S. My special thanks to Harry Stern, Manhattan Councilman-at-large, who introduced the bill naming Strawberry Fields.

LEFT: Yoko's letter as it appeared in the *New York Times* and several other newspapers on August 19, 1981, asking for donations from countries around the world to the newly conceived peace garden, Strawberry Fields.

An International Garden of Peace

After the naming of Strawberry Fields was official, Yoko began to create a conceptual artwork for Central Park. This was not the first time that she had worked with the natural environment for her art. Throughout her life, landscapes have held great meaning and significance for Yoko, and it was she who shaped the gardens and grounds surrounding her and John's homes in England and America. In the 1960s, she also conceived many works that invited an engagement with nature, such as these word pieces, which appeared in her book *Grapefruit*:

CLOUD PIECE

Imagine the clouds dripping.
Dig a hole in your garden to put them in.

1963 spring

WALKING PIECE

Walk in the footsteps of the person in front.
1. on ground
2. in mud
3. in snow
4. on ice
5. in water
Try not to make sounds.

1964 spring

In that tradition, Yoko Ono published her concept and vision for Strawberry Fields on August 19, 1981, in letters printed in the *New York Times*, the *Washington Post*, the *Los Angeles Times*, the *Village Voice,* and several other newspapers around the world. No sooner had this letter appeared in the papers than the offerings came pouring in. Several countries chose to send native plants: Great Britain sent an oak tree; dogwoods were donated from Princess Grace of Monaco; river birches came from the Soviet Union; maples arrived from Canada; the Netherlands sent tulip bulbs; a cedar was donated from Israel and *Fothergilla* shrubs offered by Jordan; Cuba sent two royal palms and Uruguay sent a kapok tree; and even NASA offered a seedling germinated in space. Several countries offered artifacts: A tile bench came from the Moroccans, a fountain from the French, a huge amethyst from the Paraguayans, a totem pole from the Aleutian Indians, monumental gates from Great Britain, a slab of marble from Greece, basalt paving from Portugal.[29] The Parks Department finally had to request that countries first send a picture of their proposed gift to Yoko at the Dakota before delivering the actual item.

Fans too wanted to participate and began planting strawberry plants on the Park site and gladly offered trees and bushes. *Rolling Stone*, for example, reported that the New York City Parks Department had a call from a thirty-three-year-old Pennsylvania woman, who vowed that she and a friend would "stop eating lunches for the next two weeks so we can buy a tree for Strawberry Fields."[30]

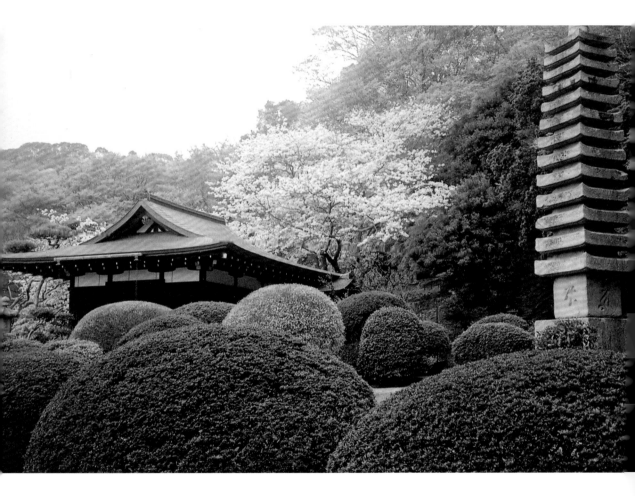

ABOVE: Ohiso House: This extraordinary naturalistic yet formal garden has belonged to Yoko's family since the Meiji period. Now, one day every year, the public can visit and enjoy the gardens. Ohiso House was the first influence on Yoko's garden designs.

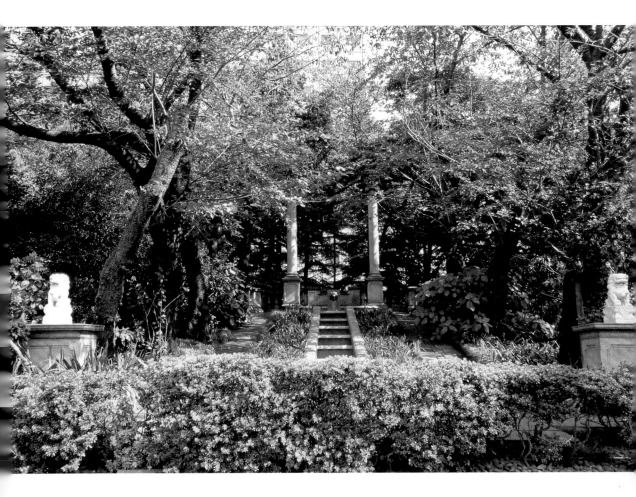

ABOVE: Kudan House: Now the Tokyo Philippine Embassy, Kudan House was one of Yoko's childhood homes. Again, the memory of this naturalistic garden later influenced Yoko's garden designs.

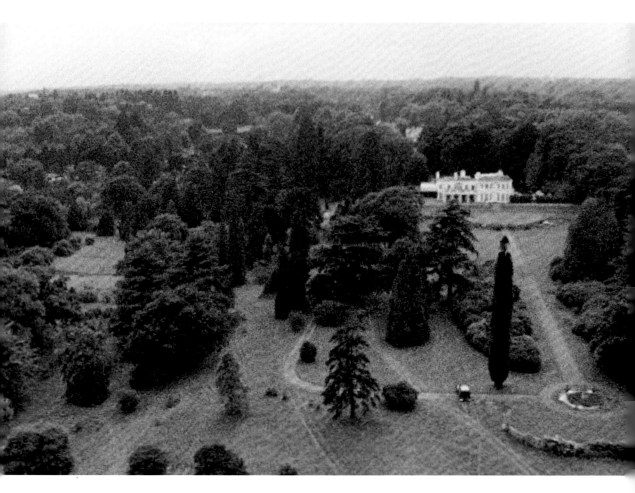

ABOVE: Tittenhurst Park: This was John and Yoko's home in Ascot, England. It was designed by Yoko to have a touch of Asian spirit. She added a large lake in the formal gardens, with an island at the center of it, like one of her mother's gardens in Tokyo.

ABOVE: Valley View Farm: The landscape view of Yoko and John's country home in the States, as it looks today. Yoko's design of this farm was based on feng shui.

The Vision of Landscape Architect Bruce Kelly

Putting forward Yoko's concept of what would become Strawberry Fields, landscape architect Bruce Kelly, interpreting her vision, created a beautiful garden of peace inspired by her plan. Kelly, a young landscape architect, historic preservationist, and Olmsted scholar, coauthored a book, *Art of the Olmsted Landscape*, and curated an Olmsted exhibition for the Metropolitan Museum of Art. When Kelly first walked with Betsy Rogers in Central Park in the summer of 1975, he helped her visualize how the badly deteriorated Park could be transformed back to the masterpiece it once was. In 1993, Rogers spoke of the valuable contribution he made:

> With Bruce's eyes informing mine I would see these abused weed-choked woodlands as Olmsted and Vaux had planted them. We would talk about how we might coax them back to ecological health, and without robbing them of their sense of delicious mystery, make them feel safe and hospitable for people once again. . . . Bruce helped me to see the Park not as a collection of objects set in a space, but as space itself, space beautifully articulated to induce a variety of moods.[31]

Kelly was working on a master plan, *Rebuilding Central Park*, for the Central Park Conservancy in 1983 when Rogers asked him to work with Yoko Ono to help fulfill her vision for a peace garden with a different concept—more nature than culture—than the object-oriented design that was

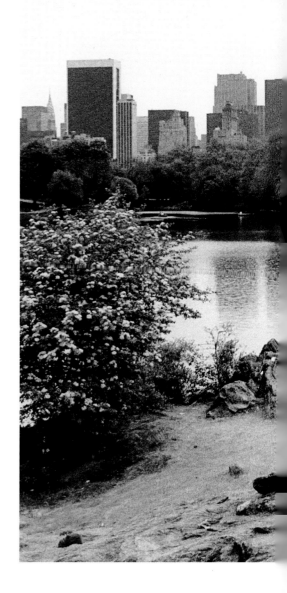

RIGHT: Bruce Kelly, an Olmsted scholar, author, and the landscape architect of Strawberry Fields, in Central Park in the 1970s.

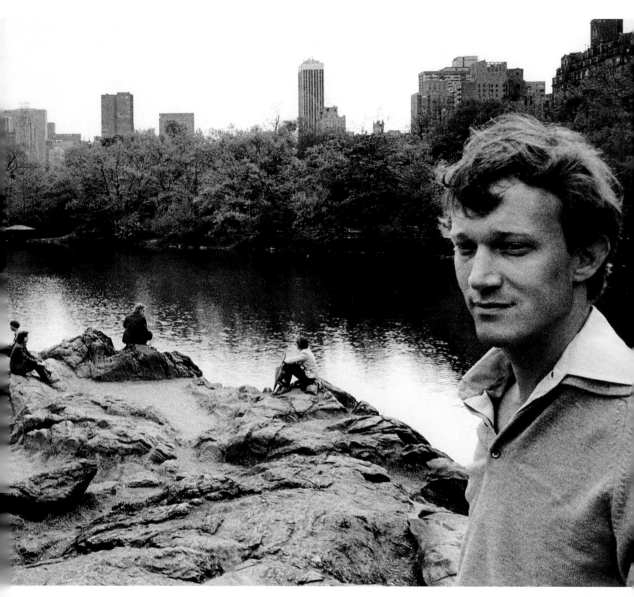

being considered. Ironically, Bruce Kelly's birthday was December 8, the date John Lennon died, which Yoko found moving. Kelly worked with Yoko to realize a naturalistic landscape that was in keeping with those that had been part of Yoko and John's life, that they had lived with and created.

Olmsted and Vaux had envisioned Central Park as an oasis from and antidote to the visual and auditory noise of the modern city. They understood that the Park's greatest gift to its citizens would be the serenity and peace that comes from nature unadorned. Fittingly for a memorial to John Lennon, Kelly understood Yoko's concept, which was similar to Olmsted's perception that landscapes of a calm and restful nature had the closest and purest connection to the effects of music. "The chief end of a large Park is an effect on the human organism by an action . . . like that of music," which Olmsted felt goes beyond thought, "and cannot be fully given the form of words."[32] Olmsted called manmade monuments in the landscape "incidents"— such as the large statue of Daniel Webster, which today stands guard just below the eastern entrance to Strawberry Fields—

RIGHT: Bruce Kelly's plan for Strawberry Fields, drawn by Perry Guillot (this watercolor-and-pencil version came later) and listing the countries and their representative plants in the garden of peace.

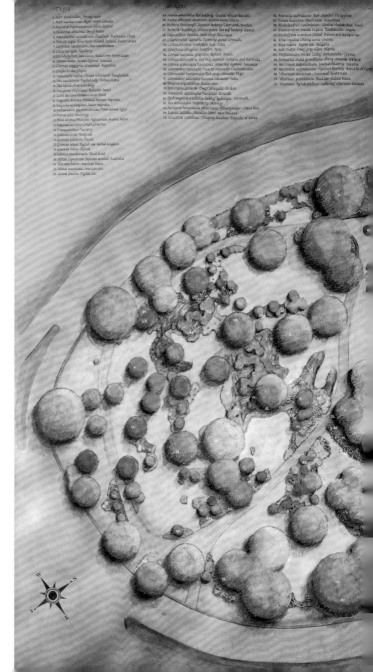

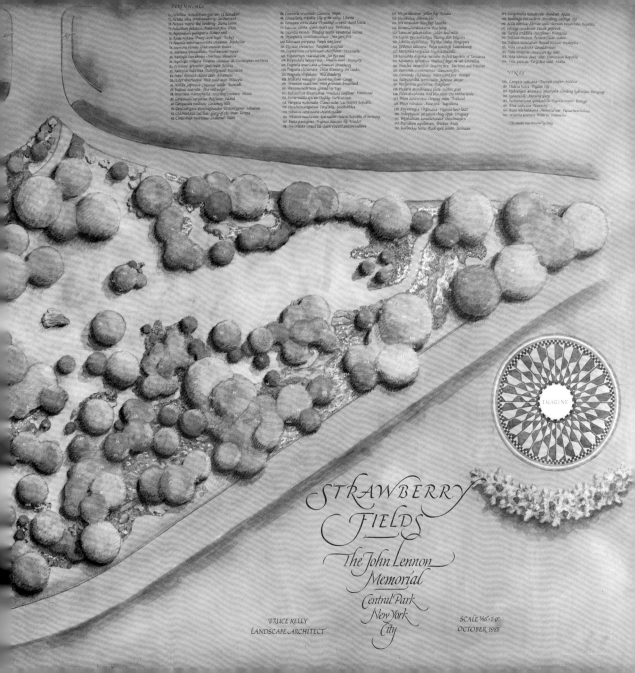

STRAWBERRY
FIELDS

*The John Lennon
Memorial*

*Central Park
New York
City*

BRUCE KELLY
LANDSCAPE ARCHITECT

SCALE 1/16"·1'·0"
OCTOBER 1985

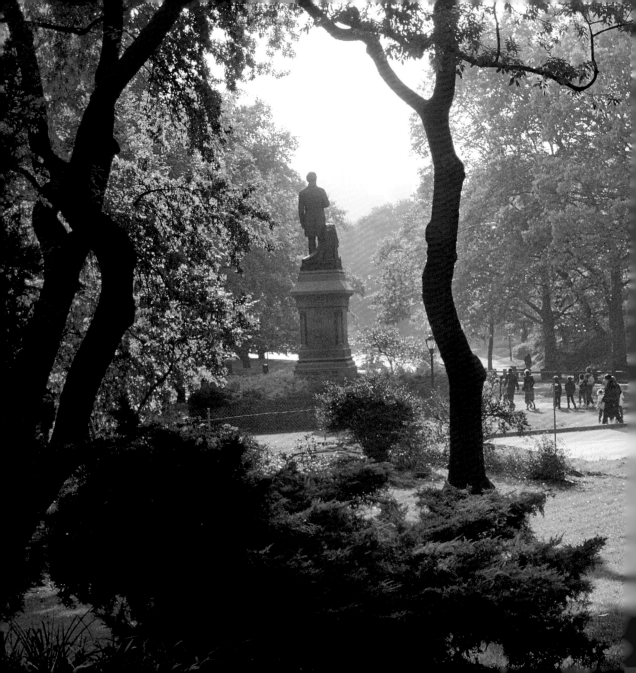

because they were *incidental* to the real purpose of the Park, which Olmsted and Vaux envisioned as a natural refuge *from* such objects and ornaments commonly found in an urban environment: ". . . the Park [is] a work of art . . . to the purpose of affording recreation by scenery from urban conditions. . . ."[33]

It was Yoko's idea to place a symbolic circle of peace in Strawberry Fields, the garden of peace. She selected an ancient mosaic design found in Naples and placed the word *Imagine* in the center. The people of Naples were delighted, and artisans were dispatched to Strawberry Fields to inlay the Imagine mosaic medallion, faithfully copying the design Yoko had chosen. The Imagine mosaic has since become the pride and joy of Naples. As Rogers recently described the emotional impact of the mosaic: "One word on the ground is infinitely more powerful than the colossal and bombastic *Daniel Webster* across the drive."[34]

Kelly drew up a list of possible plants from which countries could choose their memorial, also adding those plants and trees that had already been donated.Commenting on his plant selection, Kelly explained that "the great bulk of plants are tried-and-true hardy native Americans, and often naturalized in Central Park."[35] The list of participating countries can be seen on a plaque embedded into a rock outcrop on the east-west path bisecting the area.[36]

In the end, Central Park incorporated a landscape that is both Yoko's conceptual artwork and a new form of memorial. Yoko felt satisfied that "John would have been proud that this was given to him . . . rather than a statue or a monument."[37]

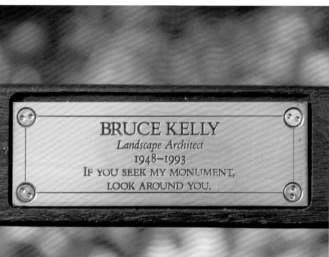

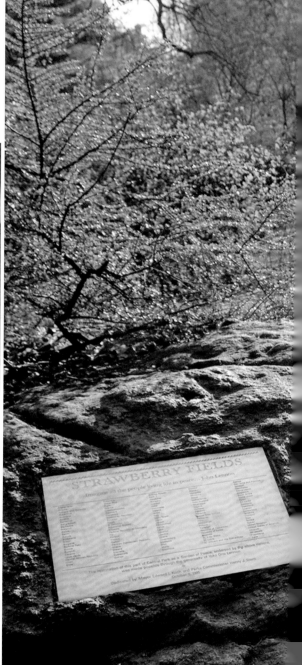

ABOVE: Though Strawberry Fields is a memorial to John Lennon, many other individuals are remembered on bench plaques. On the west side of Strawberry Fields is this dedication to Bruce Kelly, who died of AIDS in January 1993.

RIGHT: The plaque listing the 121 countries that wished to memorialize the life and work of John Lennon.

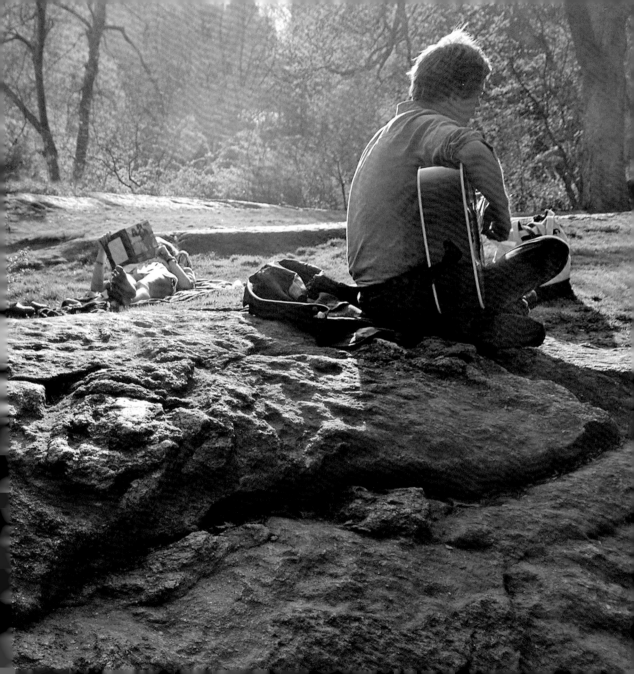

A GUIDE TO STRAWBERRY FIELDS

Bruce Kelly's most important concern while interpreting Yoko's concept for Strawberry Fields was to make sure that it would "become an integral part of Central Park and not stand out as an intrusion. It should be consistent with [Vaux and] Olmsted's overall design, a well-planned but seemingly natural landscape."[38] In conversation with Betsy Rogers, Yoko said that she felt very comfortable with the essence of an Olmsted/Vaux landscape, as it reminded her of the natural aesthetic approach of the Japanese landscape tradition.

Being an Olmsted scholar, Bruce Kelly envisioned a landscape that could be seen as a miniaturized version of the larger Park design. Olmsted and Vaux described the experience of the overall Park as "passages of scenery": a sequence of landscape "rooms" that constantly changed as the viewer strolled through the different sections. These "rooms" were designed to be one of three different landscape types: the formal, the pastoral, and the picturesque.

THE FORMAL FEATURE: THE IMAGINE MOSAIC

The Imagine mosaic is the heart and social center of Strawberry Fields, a gathering spot for memorial events and photographs. The mosaic itself and its surrounding seating area features geometric shapes: a circle encompassed by rows of benches in the shape of a triangle. Originally the benches in the pre–Strawberry Fields landscape faced out

RIGHT: The Imagine mosaic, the heart of Strawberry Fields.

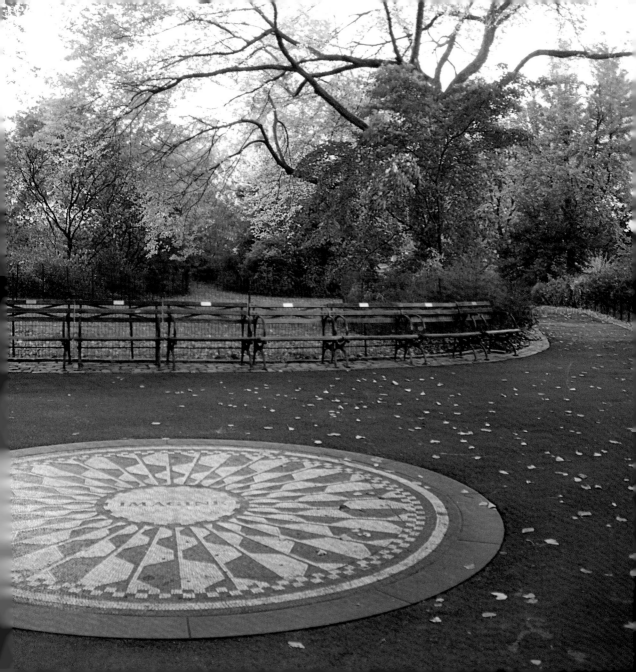

toward the traffic on Central Park West, but Kelly turned them inward so visitors could relate to one another as well as to the Imagine mosaic.

The only man-made artifact in the landscape, and the defining feature that pays homage to John Lennon, is the grey and white marble Imagine mosaic, a gift from the City of Naples, Italy. It is, understandably, Yoko's favorite part of Strawberry Fields.[39]

According to the archives of the Public Design Commission, two designs were originally submitted for the mosaic, one with Victorian motifs and one with Classical motifs. The Victorian design, created by Kelly's assistant, Perry Guillot, depicted a tendril-like form encircled by doves—the symbols of peace—and a ribbon inscribed with the word "imagine" in three places. The Classical design, a Greco-Roman sunburst chosen by Yoko was, according to her, "the one that was the most beautiful, and suited our purpose."[40] At the dedication ceremony, Yoko punned, "Since we have a Lenin Square in the world, I would like to have a Lennon Circle."

OPPOSITE: The Victorian medallion design, one of two designs that was submitted to the Public Design Commission.

OVERLEAF, Left: Yoko at the installation of the mosaic by craftsmen from Naples, Italy, on July 11, 1985. Right: Sean and Yoko at the Imagine mosaic, October 1985.

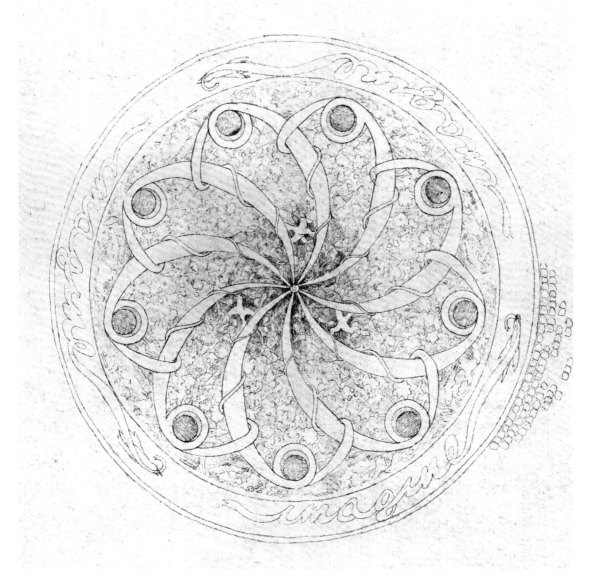

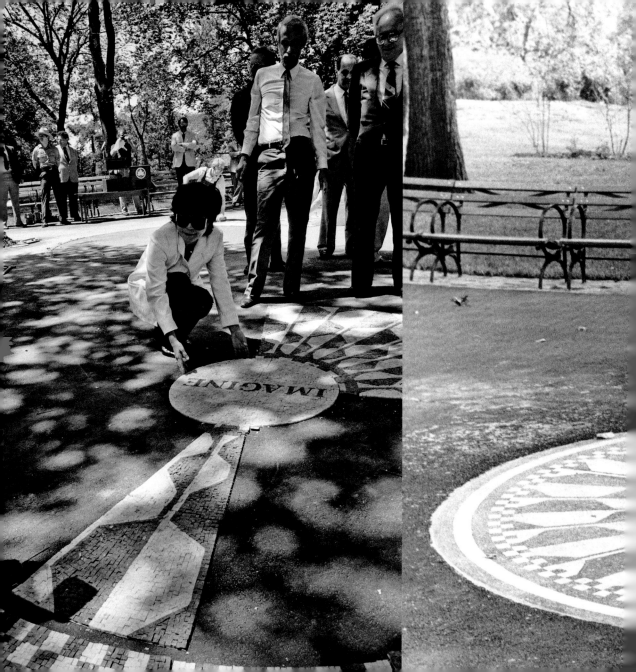

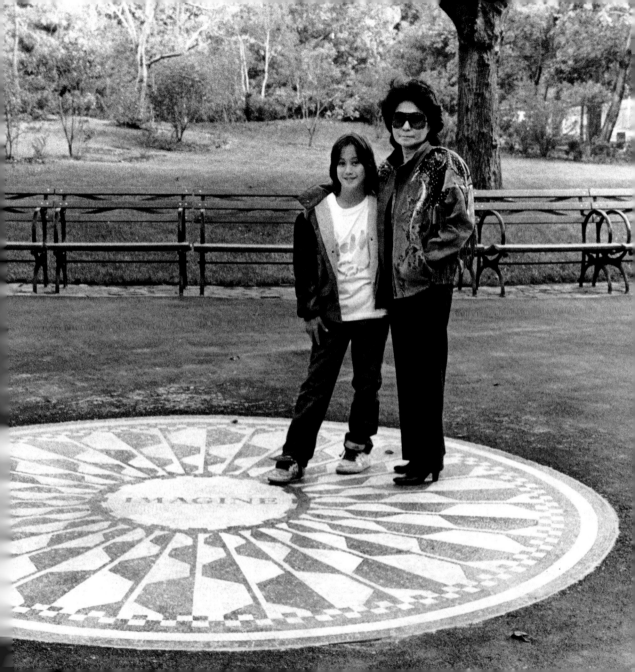

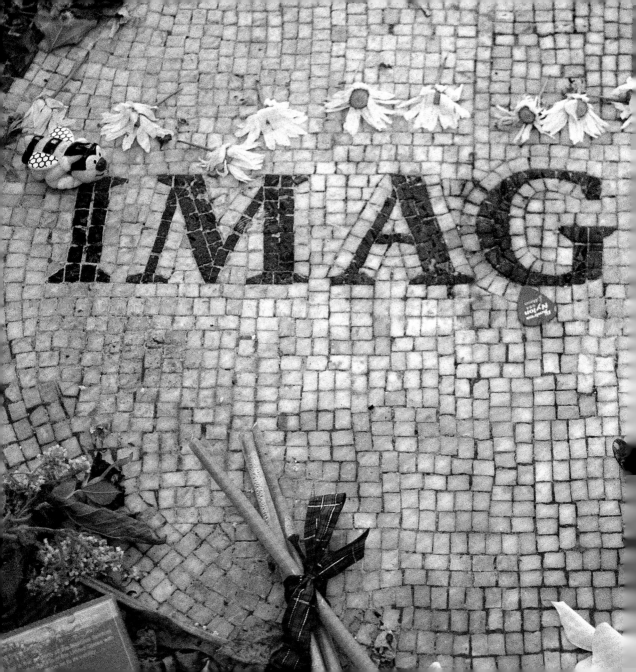

LEFT: John Lennon fans from around the world come to Strawberry Fields to pay their respects. Two of the most joyous and poignant days in the Park are the anniversary of the musician's birth (October 9) and his death (December 8) when a wide variety of flowers, offerings, and memorabilia is laid ceremoniously on the Imagine mosaic.

THE PASTORAL LANDSCAPE:
THE UPPER AND LOWER MEADOWS

The center meadow is a true greensward, featuring many
mature specimen trees that compel the eye to weave in
and out to an indefinite point in the distance. In describing
his plan for the meadows in Central Park, Olmsted wrote,
"The edges of the meadows were designed to be irregular
and indistinct so that the play of sunshine and shadow
would hint at a sense of infinite space.... [W]hat we most
want is a simple, broad, open space of clean greensward,
with sufficient play of surface and a sufficient number
of trees about it to supply a variety of light and shade."[41]
Olmstead and Vaux selected a variety of plants for their
different height, texture, color, and seasonal bloom.

Though there is no body of water in Strawberry Fields
itself, the views of the Lake and Bow Bridge enhance the
designers' pastoral idea beyond the immediate landscape,
the main reason that they wanted this space for the
Park's restaurant.

RIGHT: The upper meadow in Strawberry Fields.

OVERLEAF, Left: Rhododendrons in bloom on the woodland
walk in June. Right: The upper meadow in autumn.

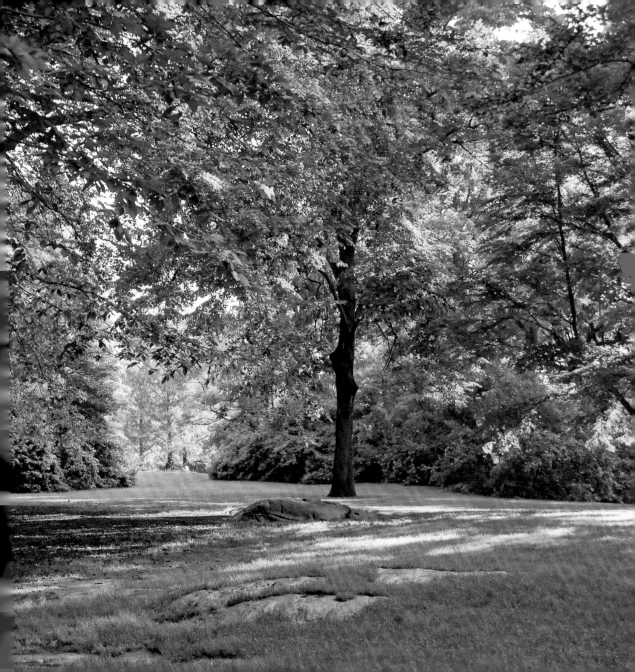

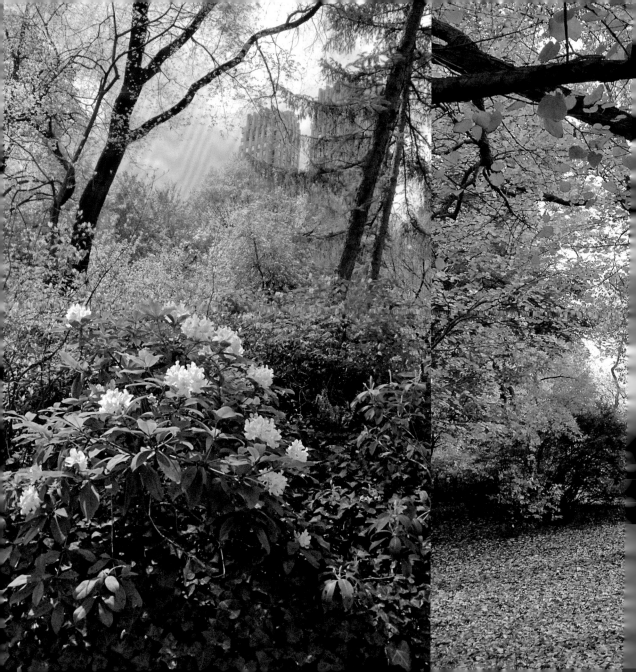

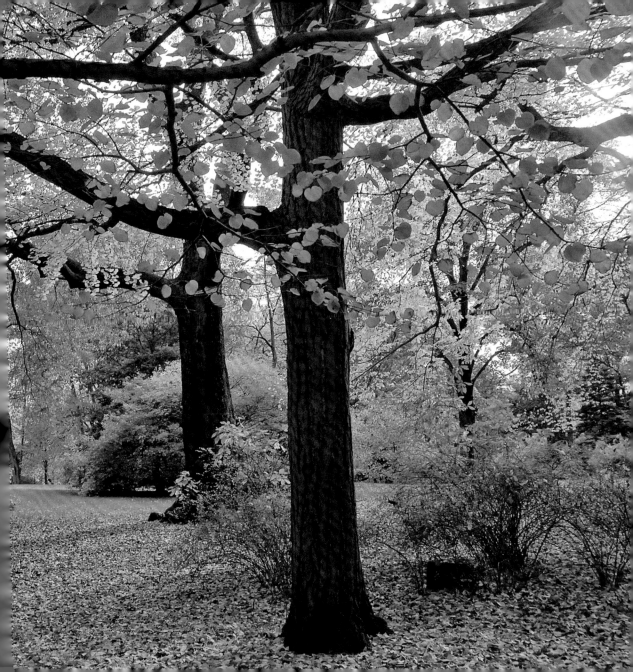

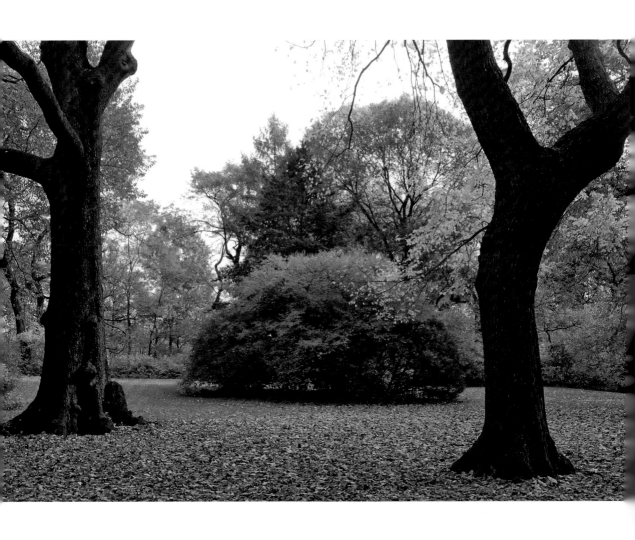

ABOVE AND OPPOSITE: The upper meadow in fall and summer.

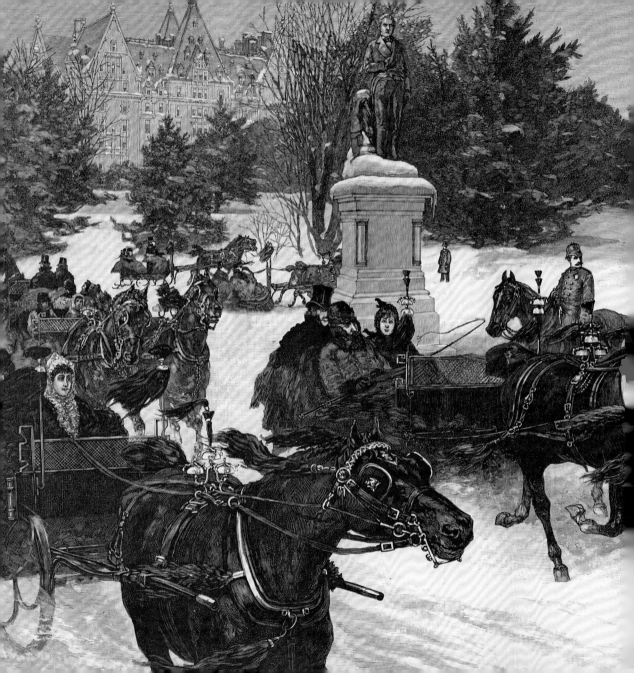

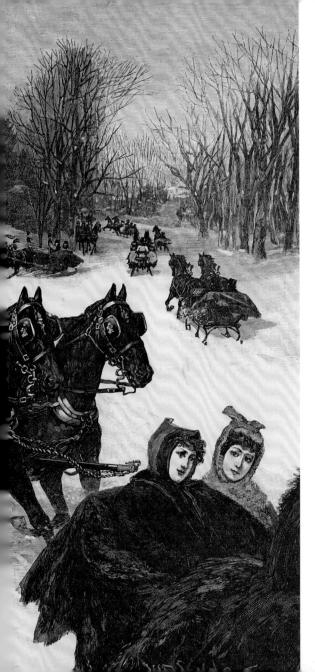

THE WINTER DRIVE

The West Drive, located between 72nd and 102nd streets, was originally created as "the Winter Drive" and was lined with a parade of evergreens for the enjoyment of winter visitors riding in their horse-drawn sleighs. In between the pines, they could catch a glimpse of the crowds of ice skaters gliding on the frozen waters of the Lake.

By 1983, most of the evergreens from the original Winter Drive had died, and not one was left in the area near Strawberry Fields. Bruce Kelly revived the Winter Drive, introducing a grove of five fifty-foot white pines (*Pinus strobus*) that command the tip of the lower meadow. They are the biggest trees ever planted in Central Park and were gifted by Afghanistan, Austria, and Belize.[42] In winter when the pines are covered in snow, it is one of the most beautiful groves in the Park.

Also for the Winter Drive, Kelly placed the twenty-five-foot-tall columnar red cedars (*Juniperus virginiana*), a gift from Israel, with the fothergilla (*Fothergilla gardenii*), a gift from Jordan. They were planted with the hope of peace.

LEFT: W. P. Snyder's 1886 *Sleighing in Central Park* depicts the original evergreen grove next to the Winter Drive with the Dakota visible in the background. Bruce Kelly revived a portion of the Winter Drive with the creation of Strawberry Fields. A copy of this etching hangs inside the entrance to the Dakota.

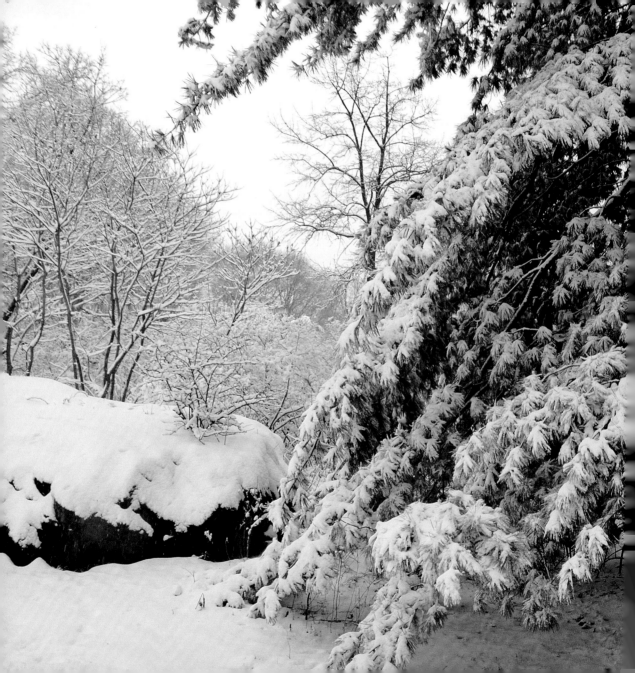

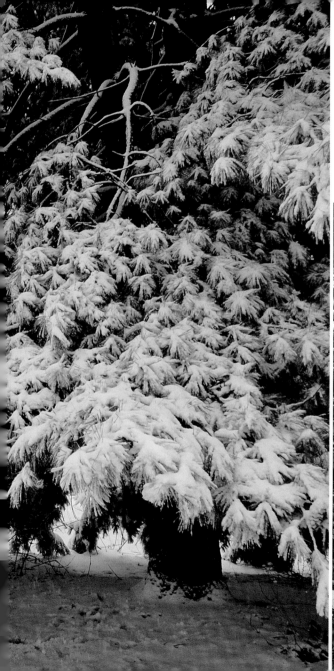

LEFT: The evergreens of Strawberry Fields are among the Park's most spectacular sites in a snowstorm. The five white pines at the southern end of Strawberry Fields are the largest trees ever planted in Central Park.

BELOW: A grove of English hollies represent the United States in the garden of peace.

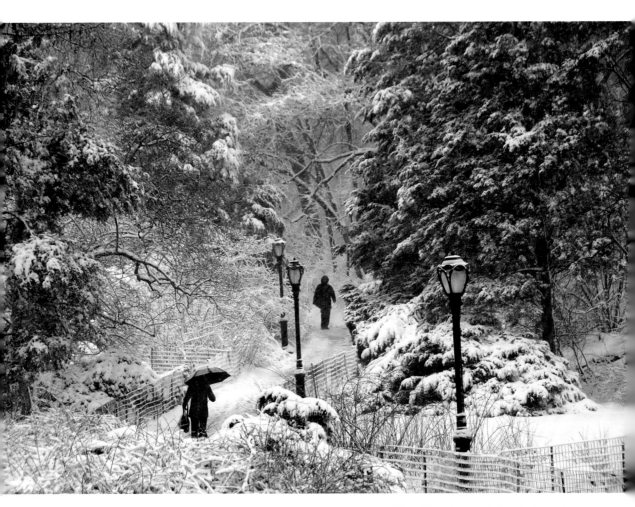

ABOVE: The celebrated Central Park luminaries line the walkway of Strawberry Fields.

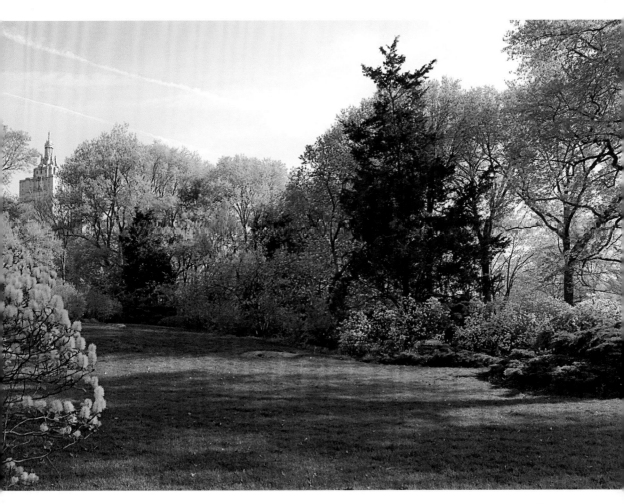

ABOVE: In the garden of peace, the white flowers of the fothergilla, representing Jordan, are planted next to the dark branches of the red cedar, representing Israel.

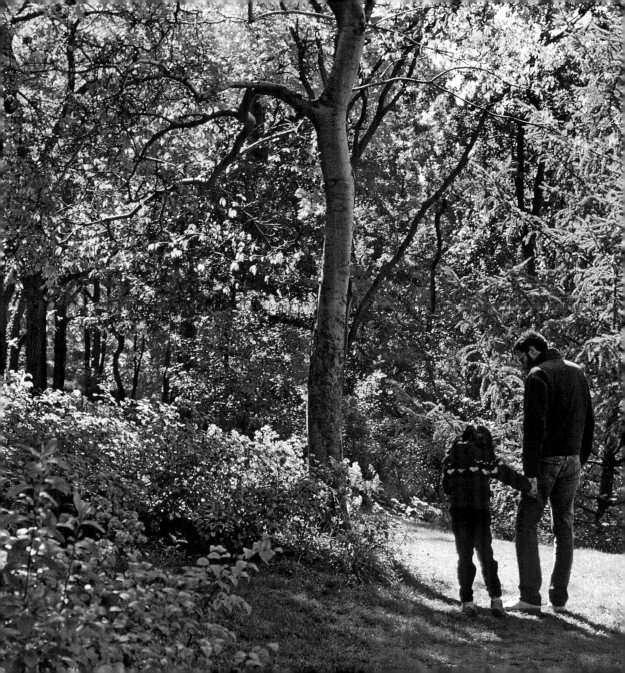

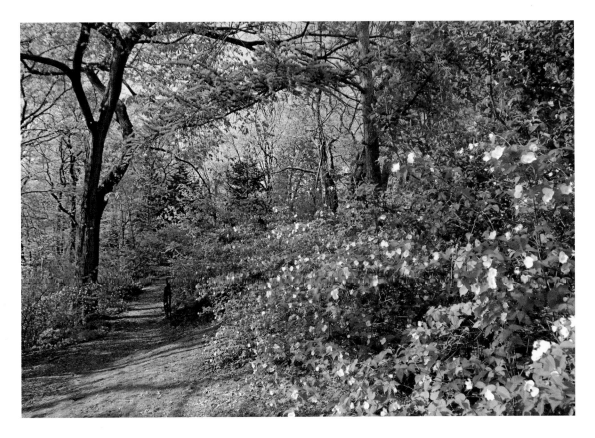

THE PICTURESQUE LANDSCAPE:
THE WOODLAND WALK

The picturesque woodlands in the Park are designed to give the visitor a sense of mystery and adventure, with dense plantings that evoke an authentic wilderness experience. Although Strawberry Fields' woodland walk features views of the Lake and West Drive, it still has some private areas where the tall trees and shrubbery envelop the visitor and offer a very solitary experience.

OPPOSITE: The woodland walk in spring.

ABOVE: Jet bead, also known as Japanese black bead, lines the woodland path in spring.

OVERLEAF: The woodland walk during the seasons.

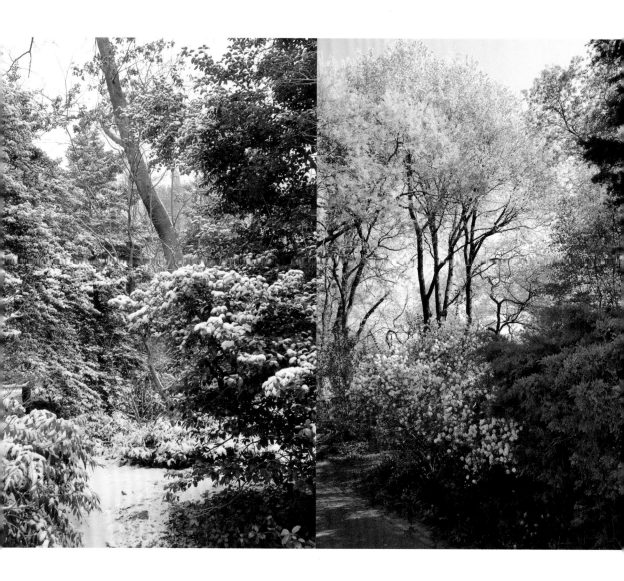

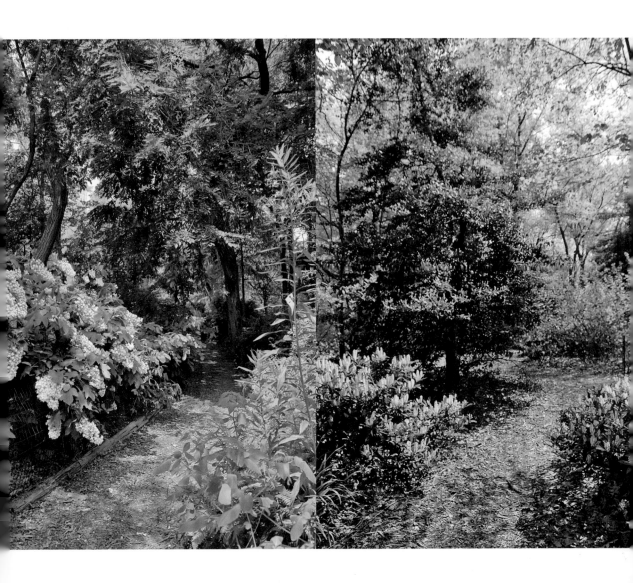

BELOW: This magnificent gingko tree graces the eastern entrance to Strawberry Fields.

RIGHT: Central Park is one of the top birding sites in North America, lying directly on the path of the Atlantic Flyway. Birders are often sighted in Strawberry Fields, particularly during the spring and fall migrations.

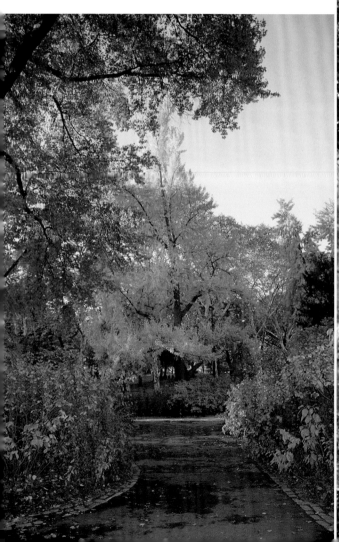

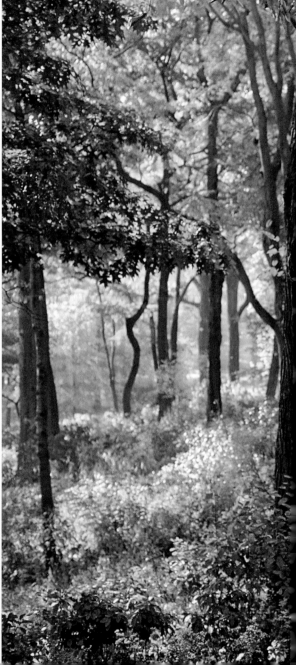

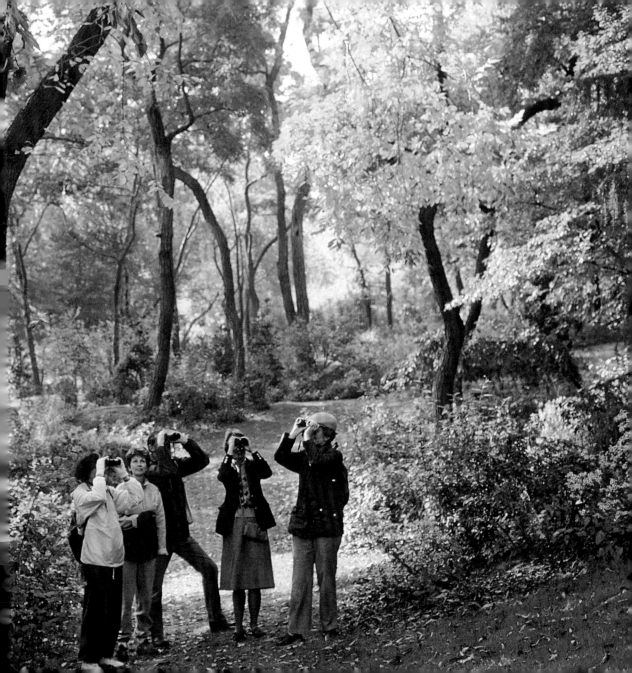

The woodland walk meanders along the eastern slope of Strawberry Fields and features shrubs and flowers that provide a variety of seasonal colors and attract migrating birds—and birders—to the area.

When the Park was first created, the gardeners placed small plants in the crevices of the massive rock outcrops. Bruce Kelly revived the tradition by placing cascading *Phlox* on the east-facing slope of Strawberry Fields.

THE STRAWBERRIES

Strawberries were part of Kelly's original plan, with the intention to introduce ten thousand plants of two different varieties: *Fragaria vesca* and *Fragaria virginiana*. According to Kelly, "very few of these grew . . . the seeds were entirely too delicious to survive the bird population."[43] Later he introduced another variety of strawberry plant, the Appalachian barren strawberry, *Waldsteinia fragarioides*, a variety with tiny red fruits that appear in June and July that is scattered throughout the landscape. Fans who visit Strawberry Fields often bring a single strawberry or a carton of berries from the local deli for their homage to Lennon.

OPPOSITE: Tiny strawberries ripen in June and July.

THE GROUNDBREAKING AND DEDICATION

With Mayor Koch, Commissioner Stern, Betsy Rogers, Bruce Kelly, and a host of New York City officials and guests, John Lennon's family—Yoko Ono, Sean Ono Lennon, and Julian Lennon—presided over the dedication of the landscape on October 9, 1985, which would have been John's forty-fifth birthday and was his son Sean's tenth birthday. Yoko, so eloquently evoking the words of "Hey Jude," remarked that Strawberry Fields is "our way of taking a sad song and making it better."[44]

Similarly, Central Park was created in the 1850s to make New York a better place, too. It was envisioned as the result of America's first wave of immigration. The new arrivals, mostly the Irish and the Germans fleeing poverty and oppression, came to this country with a dream of hope, freedom, and equality. They were saddened to find themselves in yet another unwelcoming and unappreciated environment. A group of social and political visionaries banded together to create a beautiful public space—Central Park—in the hope that it would bring people together to teach and celebrate multicultural harmony and understanding. A park, they reasoned, would lessen the tensions caused by a lack of exposure to cultural differences. Communion with nature was the powerful healing force for the human spirit and could provide common ground. Their foresight bore fruit, and urban parks were created around the nation and the world to replicate the ideals and goals so successfully planted in Central Park.

John Lennon's song "Imagine" and Yoko Ono's conception for an international garden of peace together celebrate the same democratic and utopian vision that inspired the creation of the Park. Strawberry Fields, a landscape that honors and symbolizes those ideals, offers visitors the perfect environment in which a world at peace can easily be imagined.

OPPOSITE: The groundbreaking for Strawberry Fields took place on March 21, 1984. From left to right: Parks Commissioner Henry Stern, Sean Ono Lennon, Yoko Ono, Julian Lennon, and Mayor Koch.

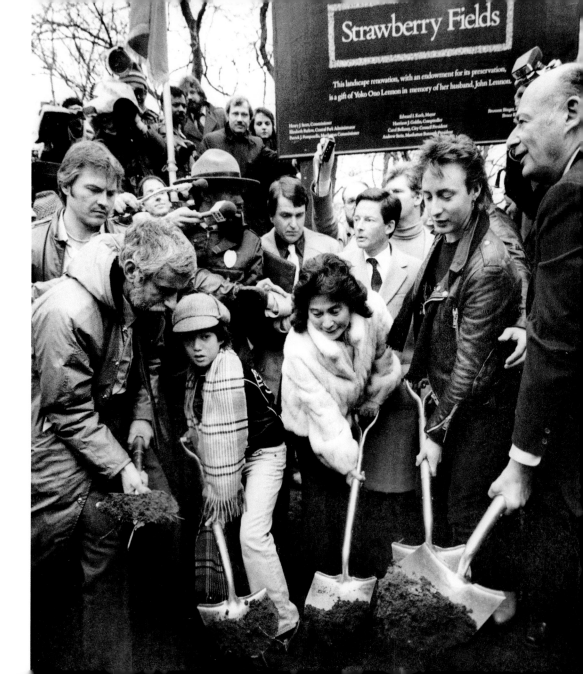

Strawberry Fields

This landscape renovation, with an endowment for its preservation,
is a gift of Yoko Ono Lennon in memory of her husband, John Lennon.

RIGHT: This planting of an English oak tree in Strawberry Fields took place on October 9, 1998. Organized with the Liverpool City Council and attended by Herbert E. Herrity, the Lord Mayor of Liverpool, this event commemorated the common bond between New York City, John Lennon's adopted home, and Liverpool, England, John's birthplace. The tree was planted as a reminder that John, like this tree, had set down roots in New York, forever binding the two cities together. From left to right: Deputy Mayor Rudy Washington, Shelagh Johnston of Liverpool, Parks Commissioner Henry Stern, Yoko Ono, and Lord Mayor Herbert E. Herrity.

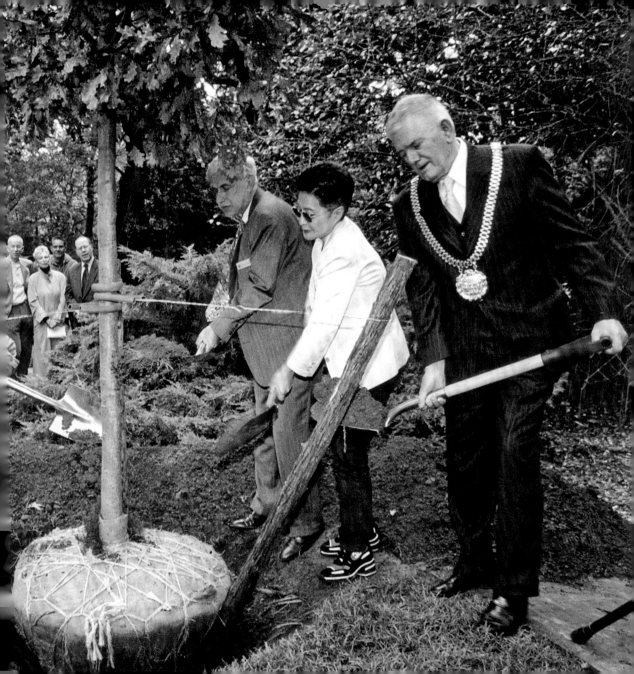

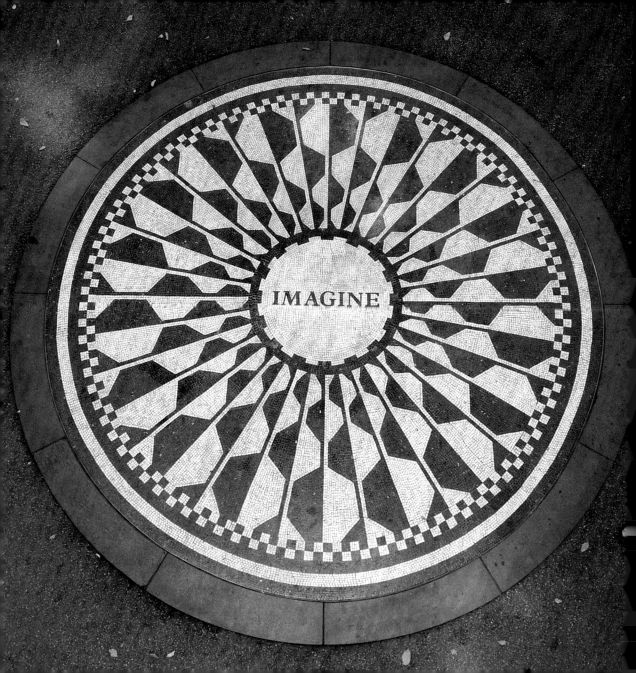

IMAGINE

BY JOHN LENNON

Imagine there's no Heaven
It's easy if you try
No hell below us
Above us only sky
Imagine all the people
Living for today

Imagine there's no countries
It isn't hard to do
Nothing to kill or die for
And no religion too
Imagine all the people
Living life in peace

You may say that I'm a dreamer
But I'm not the only one
I hope someday you'll join us
And the world will be as one

Imagine no possessions
I wonder if you can
No need for greed or hunger
A brotherhood of man
Imagine all the people
Sharing all the world

You may say that I'm a dreamer
But I'm not the only one
I hope someday you'll join us
And the world will live as one

ENDNOTES

1. Charles Beveridge and Paul Rochelau, *Frederick Law Olmsted: Designing the American Landscape* (New York: Rizzoli, 1995), 35.
2. Michael Pollak, *New York Times*, September 17, 2006.
3. Calvert Vaux, "The Central Park of New York, Notes by Mr. Calvert Vaux," *New York Times*, July 10, 1864.
4. *Sixth Annual Report of the Board of Commissioners of the Central Park*, January 1863, 45.
5. Vaux, *New York Times*, July 10, 1864.
6. *Eighth Annual Report of the Board of Commissioners of the Central Park*, January 1865, 38.
7. The eighteen original gates of Central Park were named in 1862 and were dedicated to the industrious New Yorkers who were "wise enough and rich enough" to afford to build a great park. The entrance at Seventy-second Street was dedicated to all women for both their professional and domestic contributions. See *Fifth Annual Report of the Board of Commissioners of the Central Park*, "Report on Nomenclature of the Gates of the Park," January 1862, 125–36.
8. Stephen Birmingham, *Life at the Dakota* (New York: Random House, 1979), 29.
9. Birmingham, 23–24.
10. Birmingham, 25.
11. Birmingham, 15. French flats were popular in nineteenth-century Paris. Whether owned or rented, they were elegantly appointed and stately apartments. They had elevators and private accommodations, and they were lived in by a single-family. Tenements, on the other hand, were often poorly constructed and generally had a simple "railroad" layout. They were all "walk-ups," meaning they had no elevator. They were constructed for low-income, often immigrant, families, and were frequently inhabited by more than one family per unit. Many units shared common bathing and cooking facilities.
12. Based on the 2004 selling price of $401 million for the Mayflower Hotel (now 15 Central Park West), located on the block between Sixty-first and Sixty-second Streets and between Broadway and Central Park West.
13. Birmingham, 19–20.
14. Birmingham, 14–15.
15. Birmingham, 19–20.
16. Birmingham, 34–35.
17. Yoko Ono, "Preface," in Allan Tannenbaum, *John and Yoko: A New York Love Story* (New York: Insight Editions, 2007), 10.
18. Allan Tannenbaum, interview with author, July 14, 2010.
19. *New York Times*, December 15, 1980, 1 and 38.
20. Birmingham, 147–148, 149.
21. Birmingham, 148–149.
22. Hal Aspen, "Yoko Ono, 13 A.D.," The Talk of the Town, *The New Yorker*, December 13, 1993, 55.
23. John Berendt, "Bruce Kelly, Landscape Architect," *Loss Within Loss: Artists in the Age of AIDS*, ed. Edmund White (Madison, WI: University of Wisconsin, 2001), 199.
24. Elizabeth Barlow Rogers, interview with author, June 19, 2010.
25. *New York Post*, December 19, 1980.
26. *Transcript of the Stenographic Record of the Public Hearing on Local Laws Held Before The Honorable Edward I. Koch, Mayor at City Hall, New York on April 16, 1981 at 2:30 P.M.*, 3.
27. *Transcript*, 6.
28. Ray Coleman, *Lennon: The Definitive Biography* (New York: McGraw-Hill, 1985), 441–43; Albert Goldman, *The Lives of John Lennon* (New York: Bantam Books, 1988), 254–57; Philip Norman, *John Lennon: The Life* (New York: Ecco, 2008), 460–61.
29. John Berendt, unpublished research notes for "Bruce Kelly, Landscape Architect," 9.
30. Kurt Loder, "Strawberry Fields: A Fitting Memorial," *Rolling Stone*, October 15, 1981, 50.
31. Berendt, unpublished research notes for "Bruce Kelly, Landscape Architect," 5–6.
32. Frederick Law Olmsted, "Boston: Parks and Parkways—A Green Ribbon," *Civilizing American Cities: Writings on City Landscape*, Part 3, ed. S. B. Sutton (New York: Da Capo Press, 1997), 261.
33. Frederick Law Olmsted and Calvert Vaux, "Letter I," *Forty Years of Landscape Architecture: Central Park*, ed. Frederick Law Olmsted Jr. and Theodora Kimball (Cambridge, MA: MIT Press, 1973).
34. Rogers, interview with author, June 19, 2010.
35. Berendt, unpublished research notes, 11.
36. The list is on the drawing "Strawberry Fields: The John Lennon Memorial" (see pages 54–55), dated October 1985. The artwork is by Perry Guillot. Kelly noted that many officials asked him to choose the plant that would represent their country in the memorial (see "Strawberry Fields: Its Plants and Trees," *Garden*, May/June, 1986, 2–7. New York).
37. Yoko Ono, letter, "Strawberry Fields Forever," *New York Times*, August 19, 1981.
38. Berendt, unpublished research notes, 9.
39. Yoko Ono, e-mail to author, May 15, 2010.
40. Yoko Ono, e-mail to author, May 15, 2010.
41. Olmsted and Vaux, "A Review of Recent Changes, and Changes which have been Projected, in the Plans of the Central Park," Letter I, "A Consideration of Motives, Requirements and Restrictions

Applicable to the General Scheme of the Park," January 1872, quoted in *Forty Years of Landscape Architecture: Central Park*, 248.

42. The map listing the fifty countries and their symbolic plants is printed on the inside of this book's jacket.

43. Berendt, unpublished research notes, 11.

44. Tim Burton, *Daily News*, October 10, 1985, 28; Maureen Dowd, *New York Times*, October 9, 1985, B1, B11.

ACKNOWLEDGMENTS

All books are collaborations and this one is no exception. First I would like to express my gratitude to Yoko Ono for her support and important contributions to the book. Her staff and advisors, in particular Karla Merrifield, Jon Hendricks, Jonas Herbsman, and David Warmflash, were tremendously helpful throughout the process.

Many people gave firsthand accounts of Strawberry Fields' development over time, in particular former Park Commissioners Gordon Davis and Henry Stern, and Conservancy Founder and Life Trustee Betsy Rogers. Author John Berendt and landscape architect Perry Guillot had been close friends and colleagues of Bruce Kelly, and they helped me fill in many blanks about Bruce's life and work. Photographer Allan Tannenbaum graciously agreed to be interviewed, which brought the last few weeks of John and Yoko's life together into perspective.

I would also like to thank Judy and John Angelo; Karen Ginman, New York Public Library; Marilyn Kushner, New-York Historical Society; Emily Rich and Adrienne Asencio, Landmarks Preservation Commission; Daniel Peters, Hal Leonard Corporation; and Jeffrey Sado for their help with the text.

Assembling the photos was a massive undertaking. I am grateful to Christine Benson, Parks Photo Archives; Keri Butler, Public Design Commission of the City of New York; Kenneth Cobb, Department of Records and Information Services of Municipal Archives of the City of New York; Mary Engel, Ruth Orkin Archives; Ken Frydman, Source Communications; Eleanor Gilliers, New-York Historical Society; Jonathan Kuhn and Malcolm Pinckney, New York City Department of Parks and Recreation; Chris Lane, The Philadelphia Print Shop; Chuck and Carol Mutterperl; Cynthia Larson Richard and Mara Richard; Pam Tice; and Eileen Travell.

I would also like to thank photographer Bob Gruen and his studio manager Sarah Field, as well as photographer Allan Tannenbaum for contributing their photographs of John Lennon and Yoko Ono to the book.

Getting the rights and doing the paperwork was no small task. I am grateful to my Conservancy colleagues Donna Capossela, Kelly Carroll, Tsay Huang, and Alicia Paez for their contributions.

Many of my past and present colleagues and friends at the Central Park Conservancy gave advice, information, assistance, and encouragement for the project. My greatest thanks, as always, is to President Doug Blonsky, who approved the project, and to Bill Berliner, who spent countless hours identifying the horticulture of Strawberry Fields for the map on the inside jacket. My gratitude also goes to Lane Addonizio, Regina Alvarez, Alice Baer, Neil Calvanese, Terri Coppersmith, Dan Daly, Matt Eggleston, John Harrigan, Maria Hernandez, Linda Heyward, Andrea Hill, Bobbi Kravis, Chris Nolan, Kathryn Ortiz, Matthew Reiley, Diane Schaub, Jonathan Taub, and Marie Warsh.

For their legal assistance, I am grateful to my colleagues Stephen Spinelli and Caroline Ruschell, and deep appreciation goes to Trustees Ira Millstein, Ken Heitner, and Linda Braun of Weil, Gotschal, & Manges, LLP.

I am immensely grateful to my editor at Abrams, Andrea Danese, who was encouraging and persistent when we first conceived of the book while working on *Seeing Central Park*. Her patience is much appreciated and her talent and insight was most valuable; also thanks to Abrams designer Sarah Gifford for a beautiful design, and to assistant Caitlin Kenney and production manager Jules Thomson. My appreciation goes to Eric Himmel for bringing me and the Conservancy into the Abrams family.

My personal gratitude, as always, goes to my daughter Alison Miller.

And lastly, I would like to dedicate this book to the memory of Bruce Kelly, who, as a consultant to the Central Park Conservancy, contributed so much toward the transformation of Central Park.

Editor: Andrea Danese
Designer: Sarah Gifford
Production Manager: Jules Thomson

Cataloging in Publication Data has been applied for and is available
from the Library of Congress.

ISBN: 978-0-8109-9786-8

Printed and bound in Hong Kong, China
10 9 8 7 6 5 4 3 2 1

Abrams books are available at special discounts when purchased in
quantity for premiums and promotions as well as fundraising or
educational use. Special editions can also be created to specification. For
details, contact specialmarkets@abramsbooks.com or the address below.

THE ART OF BOOKS SINCE 1949
115 West 18th Street
New York, NY 10011
www.abramsbooks.com

PHOTO AND MUSIC CREDITS

All photographs by Sara Cedar Miller/Central Park Conservancy,
except the following:

Central Park Conservancy Archives: pages 16; 36–37, 38–39
 (photos by Perry Guillot); 75
Bob Gruen: pages 6–7, 26, 30–31, 34, 63
Library of Congress: pages 17, 18
New York Daily News Archives, Getty Images: page 89
Collection of the New-York Historical Society, negative no. 31047:
 pages 22–23
© Yoko Ono: pages 46, 48–51
Ruth Orkin Archives: pages 52–53
Malcolm Pinckney, Parks Photo Archives, Department of Parks
 and Recreation of the City of New York: pages 90–91
Private Collection: pages 54–55
Public Design Commission of the City of New York: page 63
Matthew Reiley/Central Park Conservancy: page 92
Cynthia Larson Richards and Mara Richards: pages 44–45
Allan Tannenbaum: pages 27, 28, 32–33, 35

Map on inside jacket © Central Park Conservancy

"Cloud" and "Walking Piece" (page 47) are from *Grapefruit: A Book of
Instructions and Drawings* by Yoko Ono. © 1964, 1970, renewed 1992, 1998
Yoko Ono. By permission, courtesy of Yoko Ono.

Imagine (page 93)
Words and Music by John Lennon
© 1971 (Renewed 1999) LENONO.MUSIC
All Rights controlled and administered by EMI BLACKWOOD MUSIC INC.
All Rights Reserved. International Copyright Secured. Used by Permission.
Reprinted by permission of Hal Leonard Corporation